Mixed Media Painting Workshop

Explore Mediums, Techniques and the Personal
Artistic Journey

By Jean Pederson

NORTH LIGHT BOOKS
CINCINNATI, OHIO
www.createmixedmedia.com

contents

Gallery: Higher Ground
48" × 48" (122cm × 122cm), mixed media on canvas, collection of the artist

These flowers were a gift from a friend as I moved into my new studio. As the sun lit them in the windowsill, the flowers were calling to be painted. I painted a small maquette first on a mixed-media ground and then recreated the image on a larger canvas. I played with different mediums and had fun letting it all drip and mingle. I made marks on the surface with various objects to make a satisfying ground. The final painting shows variations of transparency and opacity where some areas show through to the original ground while other areas are covered by subsequent paints.

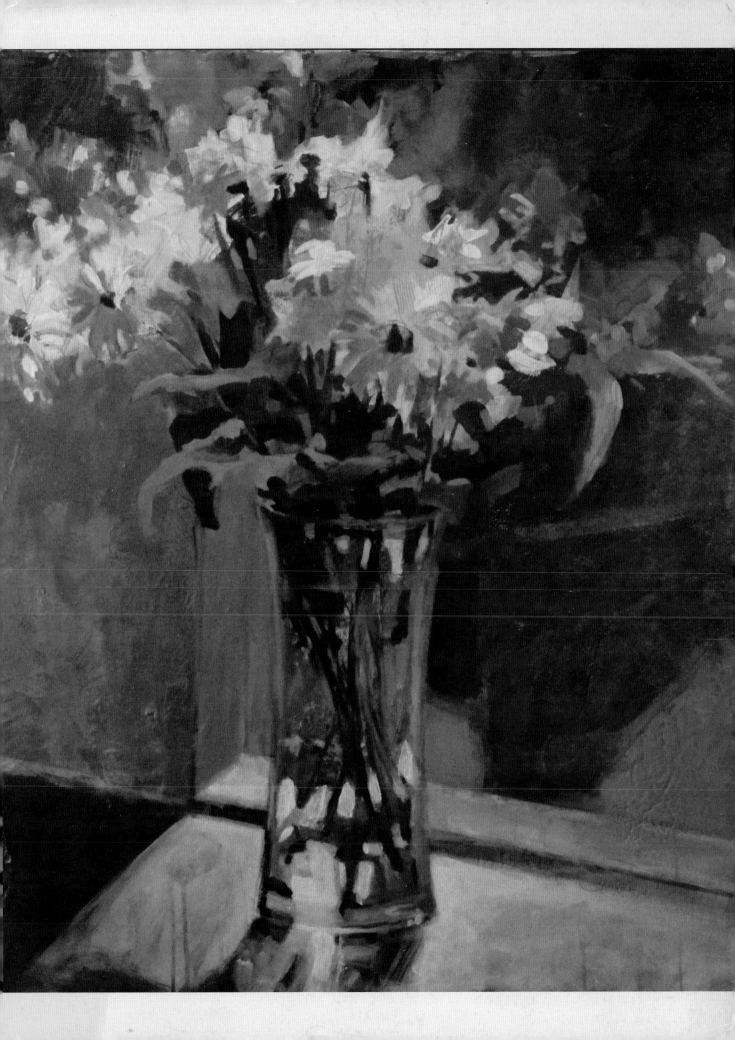

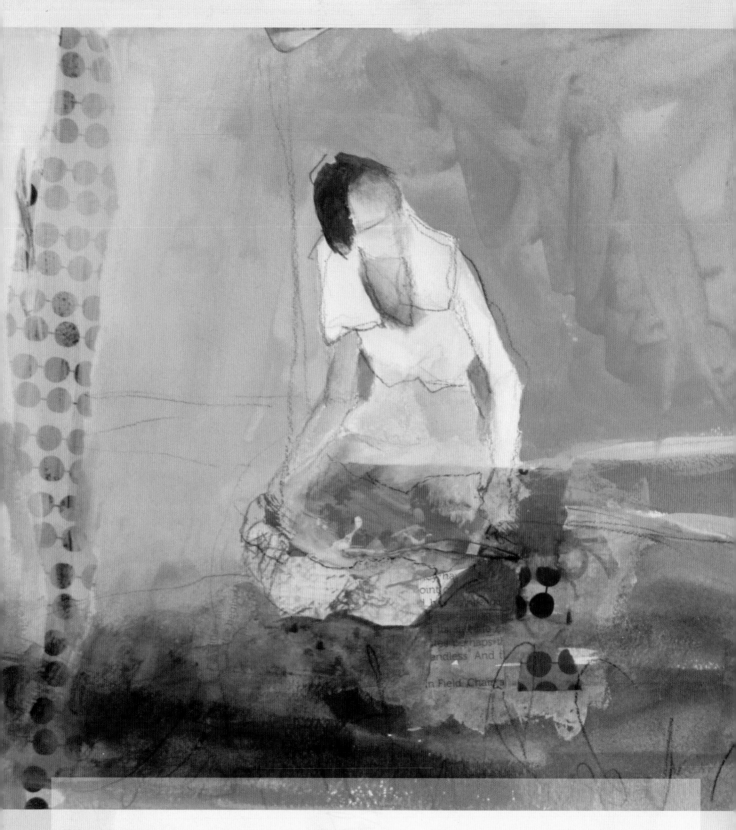

Gallery: Rest Stop
10" × 10" (25cm × 25cm), mixed media on paper

Working from a quick crayon line-drawing in my sketchbook, I redrew a simplified figure on top of a collage. Then came the fun of considering what should be concealed, obscured or emphasized within the composition! For more on collage, turn to Chapter 4.

tools and materials you'll want

The following is a list of the materials discussed, explored or used in the artwork in this book. Choose the ones that will work for you as you explore your own intentions and ideas in your paintings.

PAINTS/MEDIUMS
- acrylic ink
- acrylic paint: fluid and heavy-bodied
- chalk pastels
- colored pencils
- gesso
- gouache
- India inks
- pencils
- watercolor crayons
- watercolor paint

GELS/MEDIUMS
- clear granular gel
- crackle paste
- fiber paste
- fine pumice gel
- gloss, satin or matte medium
- heavy gloss gel
- heavy medium gel
- heavy matte gel
- molding paste
- pouring fluid
- self-leveling gel
- soft gloss and semigloss gel

BRUSHES
- ⅛-inch (6mm), ½-inch (13mm), 1-inch (25mm) hog hair flats
- ½-inch (13mm), 1-inch (25mm) nylon flats
- rugged brush for applying glue/leafing
- soft brush for removing leafing
- any others brushes you prefer to work with

SURFACES
- 140-lb. (300 gsm) cold-pressed paper
- Ampersand board factory-prepared cradled board
- board with canvas glued on top
- Masonite
- palette paper
- stretched canvas

TOOLS
- brayer
- mark-making tools
- palette knife
- scraping tools
- spatula

OTHER SUPPLIES
- board to clip paper to
- bucket of water
- bulldog clips
- collage papers
- found objects of your choice
- masking tape
- metal leaf: faux metals, pure copper leaf, variegated metal leafing, 23- and 24-kt gold or sterling silver
- old world glue
- paper towels
- plastic containers
- rubbing alcohol
- spray bottle
- tissue paper
- vellum
- wax paper

introduction

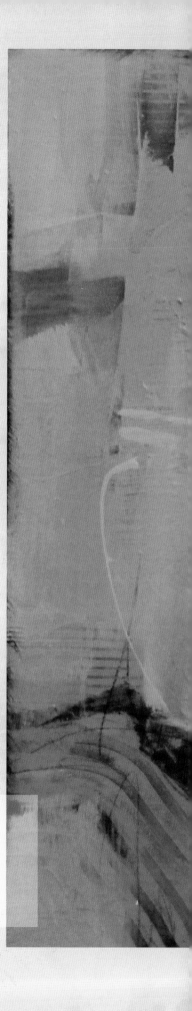

I began my artistic journey with watercolors and then incorporated gouache, acrylics, gels and collage and found objects; I can say that they all hold their magical qualities and I enjoy revisiting each. Mixed media, however, has a special allure, as each added layer matures the image. The process is seductive!

Why paint with mixed media? Mixed media makes it easy to explore and develop new ideas for our personal artistic journey. We are creatures of exploration who seek innovation, fresh ideas, approaches and perspectives.

New products come from considering different ways to integrate accessible supplies.

Technology, building structures, transportation and medicine are all examples of areas in which we can easily see great innovations; the arts are no different.

To be relevant, art needs to reflect what's going on in the world. Historically, mixed media can be found in countless works of art. One can look back hundreds of years to see paint, stone, sea shells, gold leaf, glass, wood, charcoal, wax, graphite and more—mixed to create great works of art. Artists throughout time have used anything at hand to visually communicate what is important to them.

Mixing ideas to create something new is evident in all art forms. Look at pure mediums vs. mixing media. How about modern dance—a mix of many dance styles, rock music that incorporates a symphony? Think of the Beatles as innovators, architecture that embodies new and old, steampunk art, low-rider cars, high fashion, gender bending, performance art, installations. All are genres that have been mixed.

Now we have more variety of media at our disposal to communicate our thoughts visually.

So lets explore mediums, techniques and the personal artistic journey. All you need to get started is confidence to push fear aside and see what is possible.

Invite your inner muse. Make your work meaningful, be authentic and consider your intentions. How are you going to tell your story visually? What style and mediums and elements of design will you use to develop the imagery? Let's look at our materials to gain greater understanding of their properties, explore concepts that will add visual interest to your paintings and wander through the journey of self exploration

Gallery: Figure of Elements
16" × 17" (41cm × 43cm), mixed media on cradled board

*This piece is part of the **Farm Fragments** series. I used original documents and receipts from farming and collaged them onto the surface. Some of the collage materials show through, while some are obscured. In other areas the integrity of the documents is maintained. Color choices reflect the environment of the farm and the land.*

*To see more of the **Farm Fragments** series, turn to Chapter 7.*

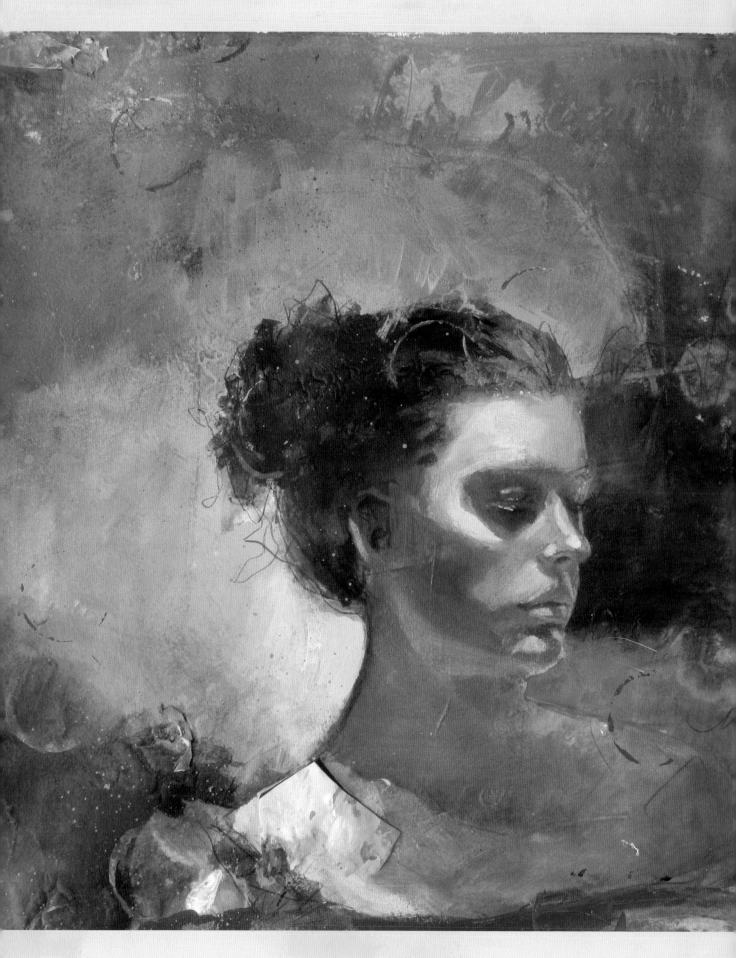

Chapter 1

Know Your Mediums: Acrylics, Gesso, Gels and More

Mixed media has become a more acceptable and mainstream means to express artistic ideas. Mixed media takes the fear out of painting as it is so adjustable and forgiving.

This is an exciting time for art and for artists. Not only are we able to experiment with traditional mixed media like linoleum, collage and found objects, but now we also have these wonderful acrylic mediums to help us tell our stories. Choices in supports, mediums and techniques are endless, their exploration seductive!

As painters, we work on two-dimensional surfaces to communicate our ideas. Using mixed media to build an alluring external skin on paper, canvas or board intrigues me. I try not to set boundaries for my work, but instead be open to discovery.

To paint your best, you need to know yourself and to use your artistic voice. You also need to understand your materials, paints and subjects so you can communicate your ideas confidently.

Let's start with the basics and learn which materials are transparent or opaque. Let's learn about their thickness or viscosity and how that relates to their interaction with water and with other mediums.

Always use the best materials you can afford to achieve your goals in painting.

Gallery: Interrupted Relief
16" × 20" (41cm × 51cm), mixed media on canvas

*Making grounds is one of the best ways to learn how your materials will interact. I love to make layered grounds using transparent and opaque paints while thinking at the same time about the viscosity of the mediums. These grounds are later used as the start to another painting. In **Interrupted Relief**, I used one such ground to build my image upon.*

Acrylics

Acrylic paint is a polymer that dries quickly as a plastic. It can't be reactivated, nor will watercolor paint adhere to it. Fluid acrylics are great for glazing, and more heavy-bodied acrylics are good for applying thick layers of paint that can be texturized.

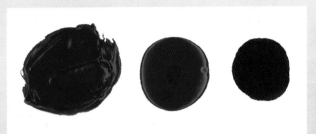

Heavy-bodied acrylic Cerulean Blue, fluid acrylic Cerulean Blue, acrylic ink Prussian Blue
Companies responded to artists' needs by creating products with the same concentration of pigment regardless of viscosity. As shown here with heavy-bodied acrylic Cerulean Blue, fluid acrylic Cerulean Blue and acrylic ink Prussian Blue, you get the same kick of color even with a thinner paint. Compare the impasto heavy-bodied acrylic with the absence of relief in the ink.

Gesso

Traditionally gesso was used as a primer for canvas and other surfaces prior to the application of paint. Today gesso is made from an acrylic polymer and contains an opacifier and absorbent agents. I like to use gesso as paint. White, tinted or watered down gesso offers many options for color, viscosity and opacity.

Gels and Pastes

Gels are transparent when dry unless the additive is opaque; if that is the case, the gel will dry opaque. Pumice gel is a good example: Pumice is opaque and so it lends this attribute to its gel form. Pastes are opaque when wet and dry. Gels and pastes both offer a range of viscosities from impasto to pourable. Impasto is the name given to thickly textured applications that appear three-dimensional. Pourable paint can be runny enough to dissipate brushstrokes. These examples illustrate how thick or thin the paste or gel is when dry.

Raw gels and pastes on white paper showing thick/thin applications:

self-leveling gel	*matte medium*	*molding paste*
soft gloss gel	*fine pumice gel*	*heavy matte gel*
tar gel	*crackle paste*	*heavy gloss gel*
clear granular gel		*fiber paste*

Transparency and Opacity

Knowing which of your paint products are transparent (see-through) and which are opaque (not see-through) will help you decide when and how to layer your paints.

In general, it's best to begin with transparent paints and follow with opaque products. The beauty of acrylics, though, is that you can cover areas with an opaque light or white color and glaze again with transparent paints.

If the packaging isn't clear, an easy way to determine transparency or opacity is to brush the paint over a black felt-pen mark. Opaque paints will cover the black mark, and transparent paints will not.

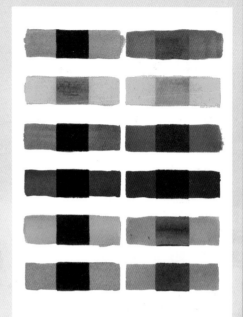

Transparency and opacity of pigments in acrylic paint
The transparent paint samples on the left have been painted over opaque black paint to demonstrate their transparency. In the samples on the right, white (in this example) has been layered on to increase opacity and reduce intensity, creating a tint or a shade.

How Transparent or Opaque Are Gels and Pastes?

These swatches show the same gels and pastes as on the previous page. On the left, clear, vivid Quinacridone Magenta is added to demonstrate viscosity and transparency. This also reveals additives such as pumice. In the middle, white gesso is added for opacity, and on the right, pure medium is brushed over wet opaque paint.

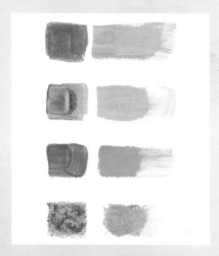
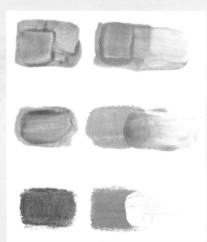
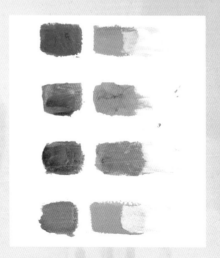

Gels and pastes with transparent acrylic Quinacridone Magenta mixed in:

self-leveling gel	matte medium	molding paste
soft gloss gel	fine pumice gel	heavy matte gel
tar gel	crackle paste	heavy gloss gel
clear granular gel		fiber paste

Covering Previous Layers

At full strength, opaque paint covers the underpainting, but when extended with water, it becomes semiopaque, revealing some of the surface beneath. Transparent paints let the surface beneath show through.

You can use a variety of techniques to emphasize a shape, unite the colors, tone the surface down a few notches or completely cover parts of the painting.

On a neutral putty-color base, I painted Pyrrole Red and let it dry. Then I explored options for covering the red underpainting. First up is fluid Teal at full intensity, then watered down to extend it and create a semiopaque area. I like the way the Teal granulated much like a sedimentary pigment reacts in watercolors.

Next up is Phthalo Blue tinted with white gesso to make it more opaque and applied and extended to expose a bit of the red underneath.

Third is white gesso, full strength and also thinned and extended.

Finally, transparent Phthalo Blue is applied. The transparent Phthalo Blue exposed the underpainting throughout at full strength and after being diluted.

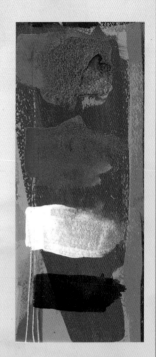

 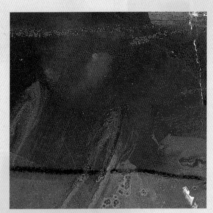

In all examples, the underpainting influences the final product, and the underpainting is subdued by the strokes of semiopaque and semitransparent paint.

In the example above a textured underpainting is covered by a stroke of semiopaque (top) and semitransparent (bottom).

In the example above, across the bottom there is a thin veil of semi-transparent gesso, which obscures the layer beneath.

In the example above, from the top left, a stroke of semiopaque gesso is gradated to semitransparent. Edges are feathered to soften the transition from this layer to the one below it. See how it reduces the intensity of the underpainting.

About Pigments	Transparent Mediums	Opaque Mediums
In general, man-made pigments are transparent, e.g., the Quinacridones. By contrast, the Cadmiums and earth colors, like Cerulean, reside on the opaque end of the continuum.	watercolors inks liquid acrylics acrylics (before black or white is added) acrylic mediums (matte, gloss, gel)	gouache gesso acrylic with white or black added collage gilding/leafing

Over and Under

Next, let's look at the wet-on-dry application of gels, pastes and transparent acrylics. To achieve our goals in painting, we also need to know how these products will interact when layered wet-over-dry. In the next examples the red side shows gels and pastes applied over dry acrylic paint to see their transparency and opacity, as well as the impasto effects of the heavy mediums. The blue side is transparent acrylic paint applied over dried gels and pastes. Note how absorbent the gel or paste is. Gloss tends to resist more, while matte tends to catch the paint.

self-leveling gel
tar gel
soft gloss gel
clear granular gel

fine pumice gel
crackle paste
matte medium

crackle paste
heavy gloss gel
heavy matte gel
molding paste
fiber paste

Viscosity

Another important concept in mixed media is viscosity—how thick or runny the paint or product. High-viscosity paints are thick and are not inclined to mix on their own. Low-viscosity paint is thinner, so it moves and mingles easily without a lot of intervention. Paints with different viscosities interact with each other differently than those of the same viscosity.

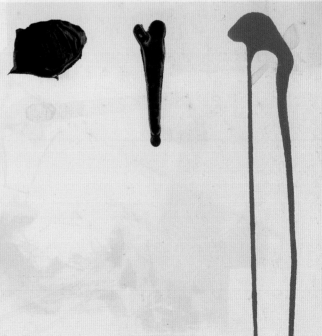

Thick or thin?
Heavy-bodied Phthalo Blue (Red Shade) is thick and moves very little. Fluid acrylic Phthalo Blue (Red Shade) has a lower viscosity and runs down a tilted surface. By contrast, the lowest-viscosity acrylic ink is most lively, dripping easily.

13

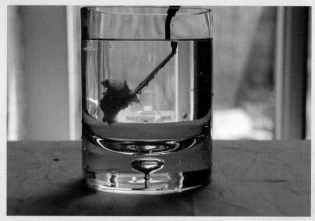

This heavy-bodied matte gel was so thick that I needed a palette knife to scoop it out of the jar. The shape of the blob did not change when it touched the water. Even after I swirled the palette knife, the gel did not change shape or dissipate.

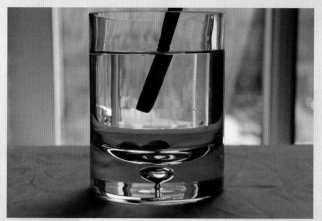

Heavy-bodied paint is less viscous than heavy gel. The blob dropped off the knife and into the water easily, but it kept the integrity of its shape with only slight dissipation until it was agitated, at which time it dissolved.

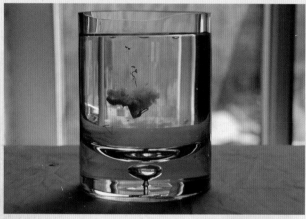

Gesso falls in a blob and begins to dissipate at the edges as soon as it hits the water. It remains somewhat consistent in shape at the bottom of the glass.

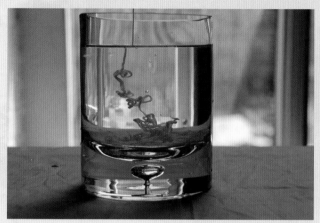

Self-leveling gel has a lower viscosity than the gesso and holds its shape as it falls through the water; however, at the bottom it spreads and loses its shape as it mingles with the water.

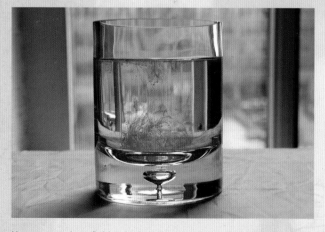

You can see how fluid paint is by its mingling interaction with water.

The Coy Shoulder
22" × 10" (56cm × 25cm), mixed media on Fabriano 140-lb. (300gsm) cold-pressed paper, collection of the artist

Thick and thin paints will interact and erode one another in the most organic ways. In **The Coy Shoulder** you can feel the texture as if a river has worn away silt on its banks.

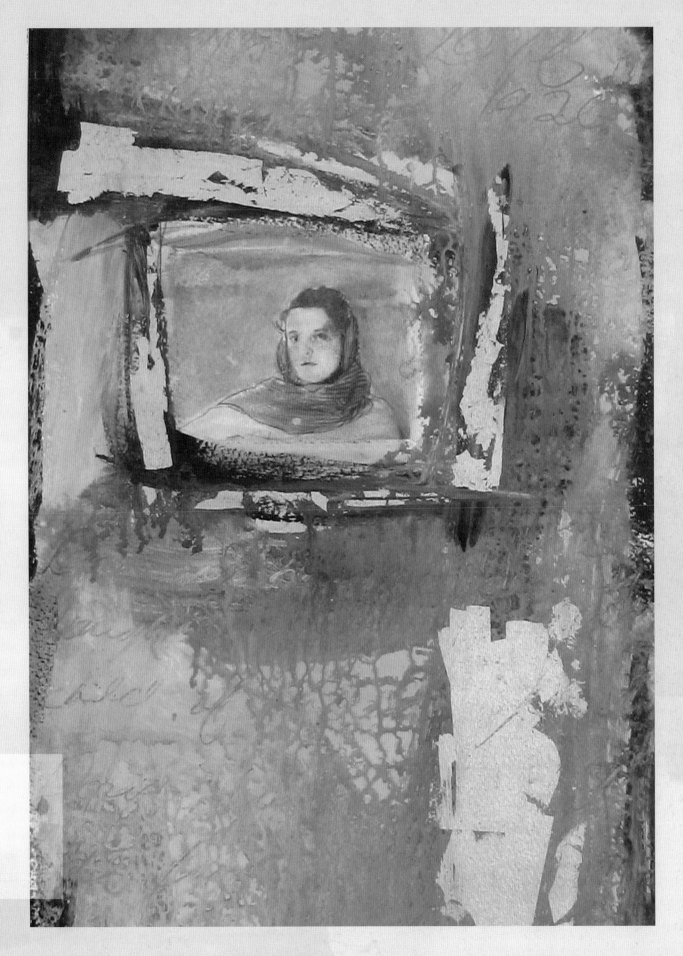

Shake, Shimmy and Glide

Watching how the paints and mediums influence one another is seductive. Have some fun, and explore the way one kind of paint pushes another away, while another kind of paint will mingle and dissipate. Understanding your materials is so important for the best success of future paintings. If you understand how the materials work, then you can apply those predictable results to adding texture in rocks, subtle shifts in foliage, interesting textures for backgrounds and more.

What You'll Need:

- board to clip paper to
- brushes: 1-inch (25mm) hog hair
- bucket of water
- bulldog clips
- fluid acrylics: Quinacridone Nickel Azo Gold (transparent), Quinacridone Magenta (transparent), Diarylide Yellow (opaque)
- paper towels
- spray bottle
- surface (I used 140-lb. [300gsm] Arches medium paper.)

Before you begin:

Clip your paper to your board using the bulldog clips. I use a light, rigid product called Gator board from the local art supply store. You can cut the board into various sizes to match the size of the paper you'll paint on. Make sure that the Gator board is slightly larger than your paper, as paper stretches when wet—you wouldn't want the paper to hang off the board and create an unwanted ridge.

1 Let a few drops of paint fall onto your paper and spread out the pigments with your brush. (I am using Quinacridone Magenta and Quinacridone Gold here.) Let the pigments mingle and add a little bit of water to encourage movement.

2 Next add an opaque pigment. (I am using Diarylide Yellow.)

3 Encourage interactions of the paint with a brush or a spray bottle, and give the surface a tilt now and then to animate the paints. The transparent and opaque pigments will mingle where they meet, creating semitransparent and semiopaque areas.

Examples of mini mingles:

This wet-in-wet mingling of a transparent fluid acrylic with an opaque acrylic pigment shows transparent, semi-transparent and semiopaque areas.

This wet-in-wet mingling shows semitransparent, semiopaque and opaque areas as well as pencil-scraped areas.

Mingling and Mayhem

This is a really fun exercise! This wet-in-wet demonstration integrates all the properties of transparency, opacity, semiopacity and viscosity. A variety of paints, gels and pastes will be allowed to interact and mingle in a wet-in-wet demonstration.

It is a good idea to start with transparent colors if you want transparency to show up. Transparent pigments will become opaque when mixed with opaque paints.

Remember there's no right or wrong way to do this. It is about getting to know your materials and how they interact with each other.

What You'll Need:

- board to clip paper to
- brushes: Use different sizes and shapes of brushes; I used ¼-inch (6mm) and ½-inch (13mm) hog hair flats.
- bucket of water
- clear granular gel
- fiber paste
- fluid acrylics: Teal, Green Gold, Quinacridone Red, Quinacridone Nickel Azo Gold, Phthalo Blue (Red Shade), Pyrrole Red, Hansa Yellow
- gesso
- palette knife
- paper towels
- self-leveling gel
- spray bottle
- surface (I used 140-lb. [300gsm] Arches watercolor paper.)

Before you begin:
Prepare your paper on your choice of support. I use bulldog clips to secure the paper to a piece of Gator board.

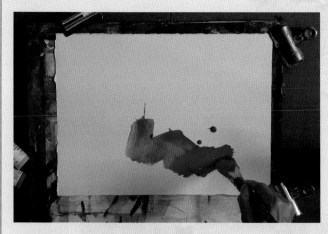

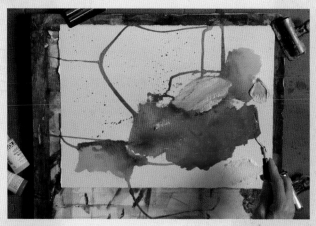

1 Beginning with Quinacridone Nickel Azo Gold and Quinacridone Red, drop blobs of each color on dry paper. Use a brush to spread the paint around the paper.

Splatter some paint from your wet brush onto the paper, and spray it with your water bottle. What happens to the mingling of colors as the viscosity changes? What happens if you tilt your surface in different directions?

Add another fluid acrylic to the mix. Encourage the paint to move by spraying the surface and tilting the board at an angle.

You can add at least 50 percent water without diminishing the integrity of the acrylic polymer.

2 Let's add a medium with heavier viscosity. I chose fiber paste, which is not only more viscous but also very opaque.

Use a palette knife to scoop the fiber paste out of the jar and spread it on your surface next to your applied paint. Try tilting your board again and spraying the mixture to encourage interactions.

Look at how wonderfully the colors move around and through the fiber paste. Some of the paste starts to dissolve and create areas of semiopacity, bridging the opaque to the transparent paint.

How would a medium with a different texture mingle with fluid paints?

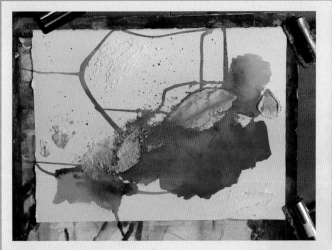

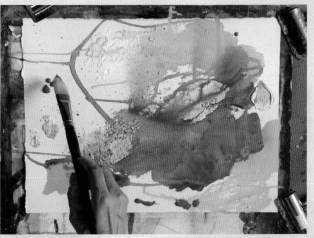

3 Using your palette knife, scoop out some clear granular gel and apply it to an area that is free of any products.

4 Add some more pigment. Let your inner child play! Try any color next—I added Hansa Yellow and Pyrrole Red—and let the paints mingle and move freely. Go ahead and jump into the process with brushstrokes or a palette knife to make marks and give your surface more variety of interactions. Add additional paints and mediums to your surface. It is fun to see how your mediums react with each other and learn their strengths and weaknesses.

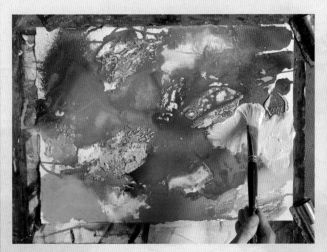

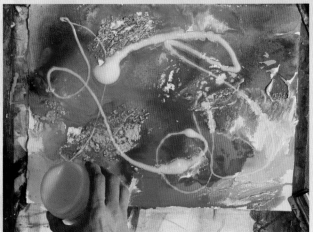

5 Try adding gesso, an opaque and relatively thick product.

6 As we are in the fun exploration mode, let's pour on a medium! Self-leveling gel pours well and gives your surface soft lines that are slightly raised. Self-leveling gel appears opalescent when wet but dries transparent and glossy.

Make interesting marks with your brush while applying self-leveling gel. See what happens when you brush self-leveling gel onto wet paint and try adding wet paint to wet self-leveling gel.

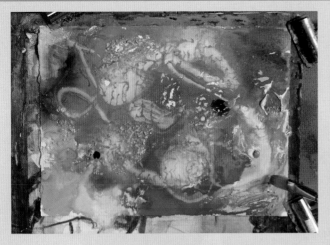

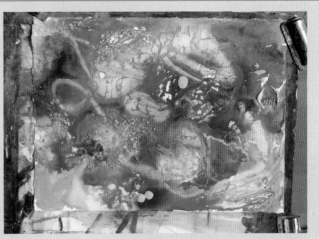

7 Explore more! I added Phthalo Blue and Green Gold fluid acrylics.

8 Watch the gorgeous ground take shape! Continue to add thick and thin, transparent and opaque, until the surface is full of an exciting array of mingles and mixtures.

9 It's a good idea to lift up your paper and clean off any wet paint or medium that may be lurking beneath as it will act as a glue when it dries, adhering your paper to the board.

To ensure your paper doesn't stick to the board, you can place some wax paper between your painting and the support board. Let your painting dry.

This close-up shows the yummy mingling of paints and mediums.

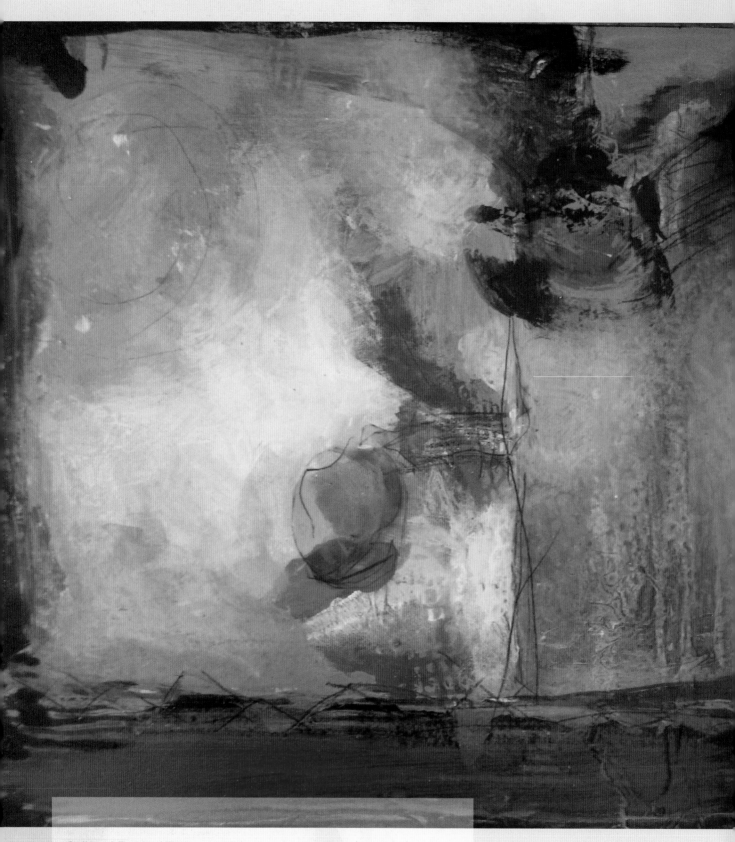

Gallery: A Touch of Blue
18" × 18" (46cm × 46cm), mixed media on cradled board

This mixed-media piece clearly shows the textures created in the underpainting. Some areas have been allowed to show through more than others as a result of transparent and opaque layering.

Contributing Artist:
Donna Baspaly

To me, seeing the painting's journey show through excites my visual senses. By deconstructing, I can use different areas of the painting to peek out of places or be obliterated.

Design is essential and by using gesso, gloss and matte mediums, I place different textures within the mediums on top of those planned bones.

When the painting is complete and I have done the best I can, I sign my name.

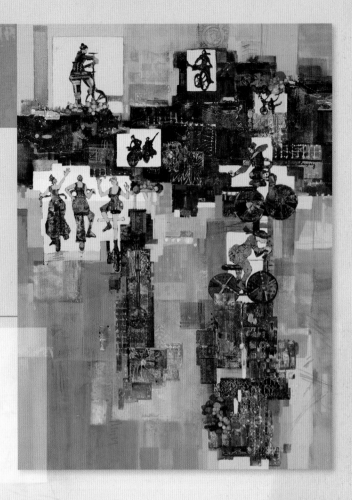

Grannies That Ride the Wild Side
40" × 30" (102cm × 102cm), mixed media on stretched canvas

With each new painting, I try to use tools in the wet mediums in a fresh way. I have options of using plastic wrap, embedding with stencils, mesh, doilies, mark-making with sticks, spatulas, knives—whatever else my imagination conjures up. This is when my inner gentle teacher and inner child work together and play to the senses. I pay attention also to connecting smaller textured shapes to lead the eye where I want. This is the time to set up dominances in rhythm, shape, size, pattern and movement.

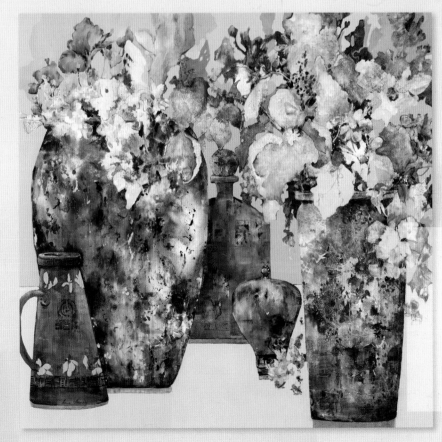

Vases in Blue
48" × 48" (122cm × 122cm), mixed media on stretched canvas

Depending on the intention of the painting, I use different gels and mediums for different reasons —but always a good artist brand. I implement the mediums at various viscosities and transparencies. Acrylic gesso can be used as a thick impasto, or it can be watered down to a light wash; juxtaposed with transparent acrylic gel mediums, gesso makes for interesting contrasts.

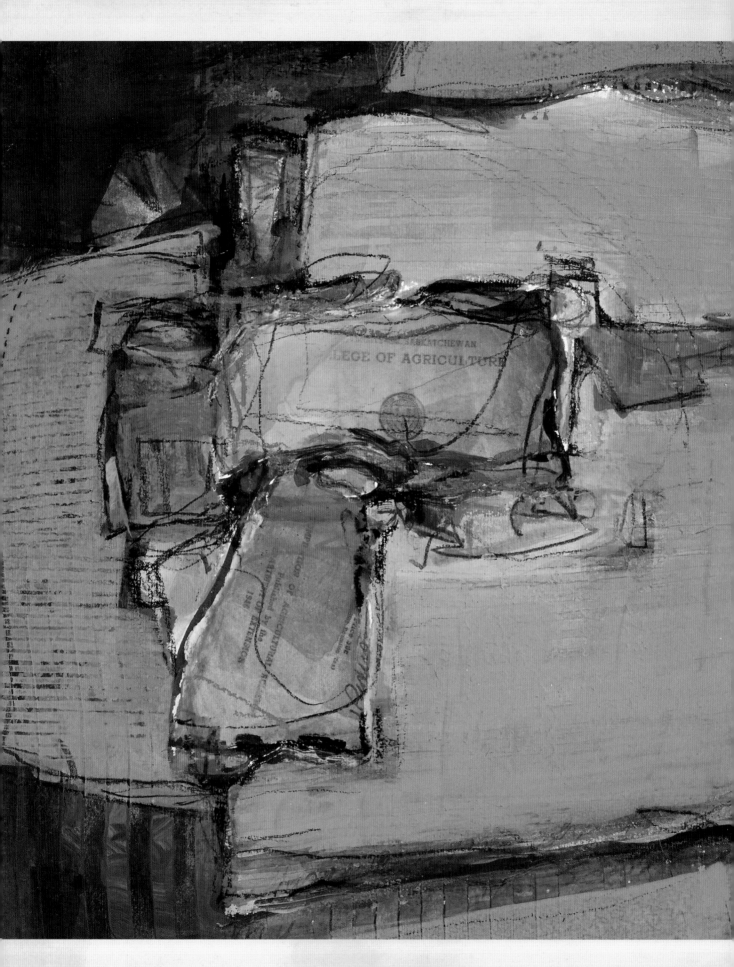

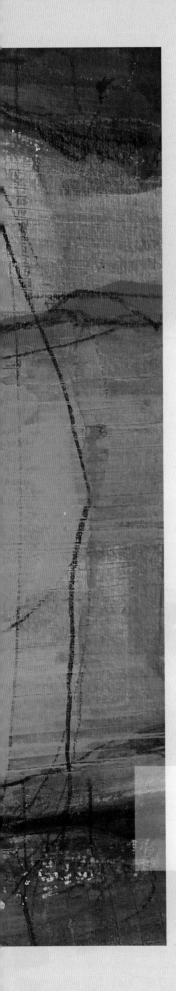

Chapter 2

The Supporting Role: Board, Canvas, Paper and Their Qualities

Now that we have discussed our paints and mediums, let's talk about the types of supports that are most commonly available to you. Knowing what you want or what your intentions are will help you to choose the appropriate surface for your painting. Things to consider are absorbency, flexibility of the surface, weight and size.

Consider this scenario: You have been asked to participate in an exhibition in a gallery several hundred miles from your studio. You will have to ship all of your paintings from your studio to the gallery. Shipping is expensive. Will you stick to small works on board or canvas to keep the weight down? Will you use paper that is lightweight and easily rolled into a tube for shipping but has a large price tag for framing for exhibition, or will you paint on canvas and roll it up with the expectation of the gallery stretching the canvas at the other end?

Let's see what our options are.

Gallery: Corporate Farming
11" × 11" (28cm × 28cm), mixed media on paper, private collection

*Your choice in paint often determines the appropriate surface. In **Corporate Farming,** gouache, a re-soluble paint, was used, and therefore paper was the natural choice. Gouache would not hold up well on board or canvas unless framed under glass.*

The Options

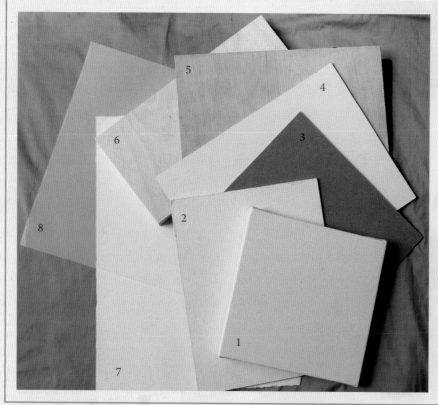

Understanding pros and cons will help you choose the appropriate surface for your intentions. Think about flexibility, absorbency, surface quality, weight, size and the mediums that will be used for painting.

1 stretched canvas
2 board with canvas glued on top
3 Masonite
4 Ampersand board factory-prepared board
5 cradled board
6 plywood
7 140-lb. (300gsm) cold-pressed paper
8 vellum

How Flexible or Rigid Is the Surface?

Can you bend the support and then have it return to its original flat shape without damage? Will your support be placed into situations where it will require rolling or bending (for example, shipping)?

Cradled board—rigid and excellent surface for heavy-bodied mediums and heavy collage items

Very flexible linen canvas

Very flexible 140-lb. (300gsm) cold-pressed paper

Absorbent or Resistant?

Does your paint sink into the surface or does it puddle on top until it dries?

Think of a cotton T-shirt becoming stained after soaking up spilled tea. Meanwhile, tea spilled on the kitchen counter sits there until it is wiped up or evaporates. The T-shirt is absorbent while the counter is impervious to liquid. Surfaces that we paint on will offer similar results.

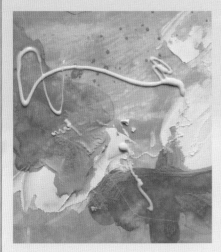

Note how various paints and mediums sit on the slick surface of the frosted vellum. It's very easy to scrape them off before they're dry, and if the medium dries brittle, then it could crack when the vellum is bent.

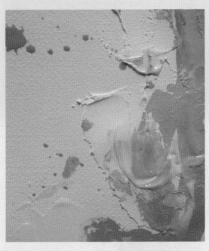

Cold-pressed watercolor paper has a tooth and accepts paint easily. Paint sinks into the surface and grabs hold, while heavier mediums stick well to paper.

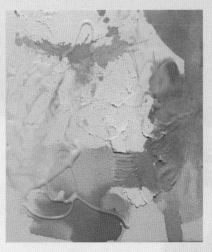

The canvas texture shows through the transparent paint.

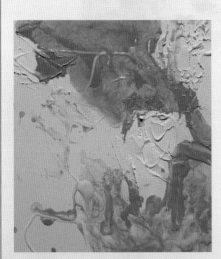

Ampersand board is a factory-prepared rigid board with a smooth surface.

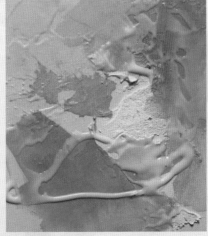

Gessoed cradled board acts much like gessoed stretched canvas.

Shiny or Matte?

Is your surface toothy or smooth? Surfaces with tooth will catch your brush and show a textural brush mark. Your brush will glide across a smooth surface with no interruptions.

So far we've looked at the reaction of paints in initial application and how they are accepted by the various surfaces. However, if you use a lot of mediums and build up the surface, then the result will be similar to what is shown in these two examples, taking into consideraation the flexibility of the surface.

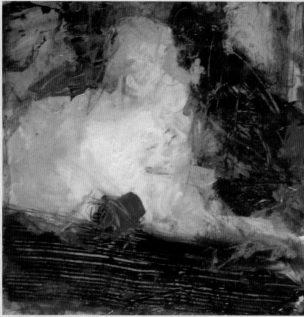

Abstract on vellum

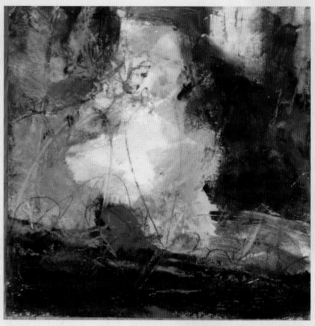

Abstract on 140-lb. (300gsm) cold-pressed paper

Weight and Size

Do you want to paint a large image or a small one? Size matters because the weight and strength of a support and its subsequent framing can be an issue with larger paintings. Paper can be purchased in large rolls. It is lightweight but may not be able to surface heavy collage within traditional paper framing techniques. If you are glazing the painting with glass or Plexiglas, the weight can become an issue. Wood is strong and rigid, great for collage, relief and three-dimensional pieces. Think about your intensions: What do you hope for a final product? Thinking it through will help you choose an appropriate surface.

Mediums

What medium do you plan to paint with? Is the medium going to be heavy or thin in application? Is the medium brittle or flexible when dry?

If using heavy mediums, including collaging heavy pieces onto a surface, consider using a heavy, rigid surface since thin flexible surfaces will bend and ruin your painting. In general, thinner applications of mediums work well on thinner, more flexible surfaces; thicker, heavier layers of mediums work better on heavier, more rigid surfaces.

Another consideration is the first few layers you will add to the surface. Do you want them to sit on the surface or sink into it? This also touches on the types of edges you can create.

	absorbent vs. impermeable	flexible vs. rigid	size: large vs. small	weight: heavy vs. light	appropriate mediums
vellum, acrylic vellum	impermeable	flexible	sheets and rolls, .005mm; rolls, up to 42" (107cm)	very lightweight; as thin as .007mm	great for all acrylic mediums; not great for heavy or brittle applications; good as a collage material
hot-pressed paper	leans to impermeable	flexible	sheets up to 40" × 60" (102cm × 152cm) in weights up to 1114 lbs. (2340gsm); rolls 140 lbs. (300gsm), 44½" × 10 yards (113cm × 9m)	lightweight	great for all acrylic mediums; not great for heavy or brittle applications; accepts collage; good as a collage material
cold-pressed paper	absorbent	flexible	sheets up to 40" × 60" (102cm × 152cm) in weights up to 1114 lbs. (2340gsm) rough; rolls 156 lbs. (330gsm) 51" × 10 yards (130cm × 9m)	lightweight	great for all acrylic mediums; not great for heavy or brittle applications unless on a very heavyweight paper; accepts collage
canvas, primed	leans to absorbent	flexible	rolls and stretched in premade sizes up to 48" × 60" (122cm × 152cm)	light-, medium- and heavyweight	great for all acrylic mediums; OK for heavy applications; accepts collage; brittle applications may crack if the canvas is bent
wood board, primed	leans to absorbent	rigid	sheets 48" × 70" (122cm × 183cm); premade cradled boards up to 48" × 60"(122cm × 152cm)	heavier, especially as size increases	great for all acrylic mediums and heavyweight collage applications

Surface Quality: Shiny and Matte, Rough and Smooth

Let's explore the idea of surface quality or finish. A painting's surface quality is usually defined in terms of the matte, satin or gloss finish on the surface. A similar finish throughout the surface can be a unifying element, but the determining factor in the final surface quality is the intention of the artist.

Matte and Shiny Exercise

This short and simple exercise illustrates the surface qualities of four gel mediums.

What You'll Need:

- 140-lb. (300gsm) medium paper
- brush (I used a ½-inch [13mm] flat nylon bristle brush.)
- masking tape
- mediums (Choose a variety of mediums with different surface qualities. I used clear granular gel, soft gloss gel, soft semigloss gel and regular matte gel.)
- opaque paint (I used Teal.)
- palette knife

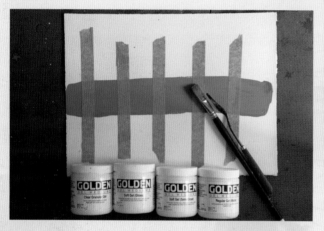

1 Paint a strip of opaque paint in the middle of the paper. Once the paint has dried, apply lengths of masking tape perpendicular to the painted stripe, creating spaces for the different gels.

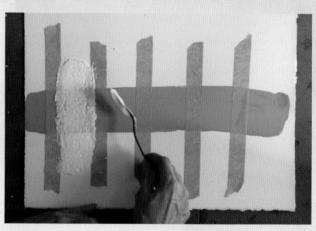

2 Apply clear granular gel in the first space.

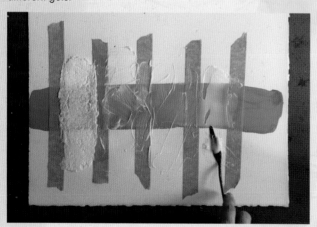

3 Apply soft gloss gel, soft semigloss gel and regular matte gel in the other spaces. I used a palette knife to scoop the gel and a brush to make strokes in the gels.

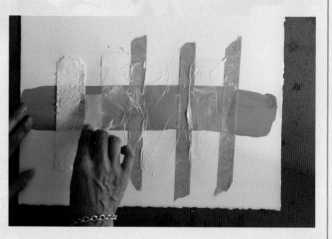

4 While the mediums are still wet, peel off the tape to leave a clean straight edge.

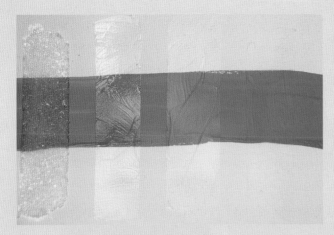

When the mediums dry, notice the variety of surface qualities that each product provides, from matte to satin to gloss finishes. From left to right: clear granular gel, soft gel (gloss), soft gel (semigloss), regular gel (matte).

A gloss finish will enhance color, creating a more vibrant and intense surface. The downside of a gloss is the distraction created by reflections caused when light bounces off the glossy plane. Matte surfaces have none of this reflection disturbance, but matte reduces the vibrancy of color in the image. Satin finishes are a compromise for those who want more vivid color but less reflection.

On this painted surface you can see uneven coverage of surface quality as there are random patches of matte and gloss throughout.

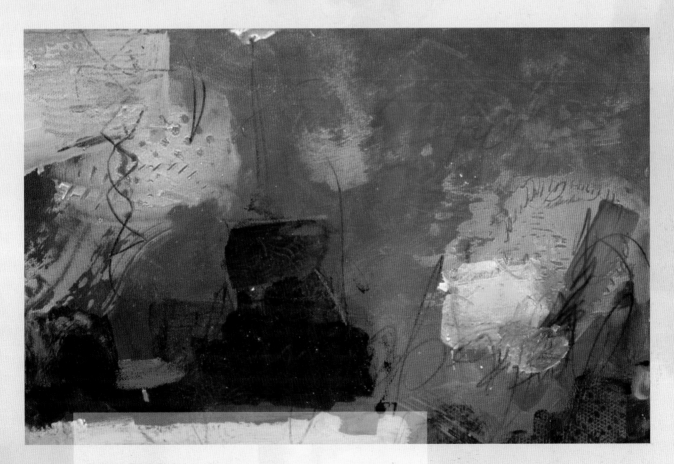

Gallery: Think Pink
10" x 14" (25cm x 36cm), mixed media on paper

I rarely use pinks in my painting, so my challenge was to create an image I enjoyed despite a color I am not enamored with. I love this painting!

Rough and Smooth

The surface of your painting can feel rough or smooth, depending on the surface you choose. Some surfaces are naturally rough, like wood prior to sanding, or inherently smooth, like vellum, which is slick.

You can also easily alter the tactile quality of your surface. Gels, mediums and collage are simple materials to start with.

Cradled board covered with gesso and pumice gel. A layer of acrylic green-gray was used to cover the gel and tone the surface with a color. The gesso and pumice gel result in a toothy surface.

This canvas was treated with several mediums: crackle paste, pumice gel, glass bead gel, and gesso and fluid acrylics. The different rough and smooth areas offer a delightful variety of brush marks and edges.

This example has multiple layers of transparent and opaque paint and a variety of marks applied to give the impression of texture. It was not until I collaged vellum onto the surface that I changed the relief of the surface and elevated its tactile effect.

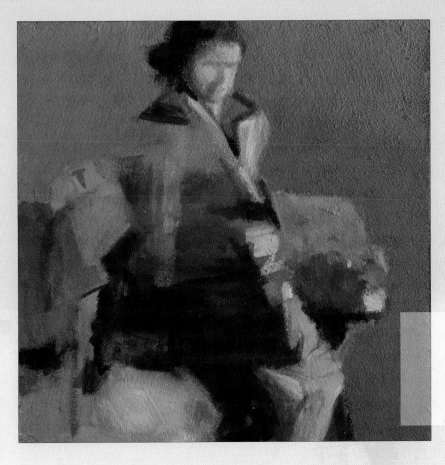

Gallery: Complements
12" × 12" (30cm × 30cm), acrylic on cradled board

This simplified figure painted on a rough surface shows wonderful irregular edges and toothy brush marks made by the brush catching the high points of the surface.

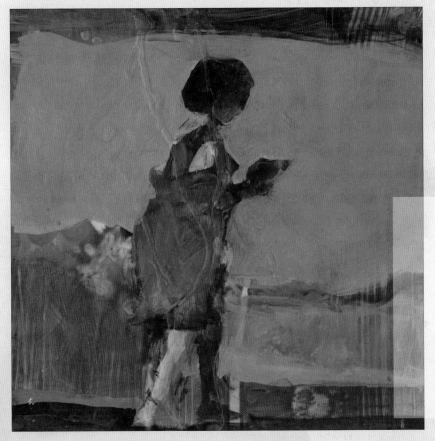

Gallery: Distracted
10" × 10" (25cm × 25cm), acrylic on vellum

What fun to paint on a slick smooth surface! I dripped tar gel on a piece of vellum and let it dry. Then I painted fluid acrylics in bright colors over the surface. These applications provided me with a base to simplify and pull out an image. The original bright colors pop out here and there, and the drizzled tar gel provides an interesting variation in the surface texture. Some mark-making tools were also used to scrape away paint, resulting in repetitive mechanical lines here and there. Note the use of transparent and opaque paint in this simple sketch.

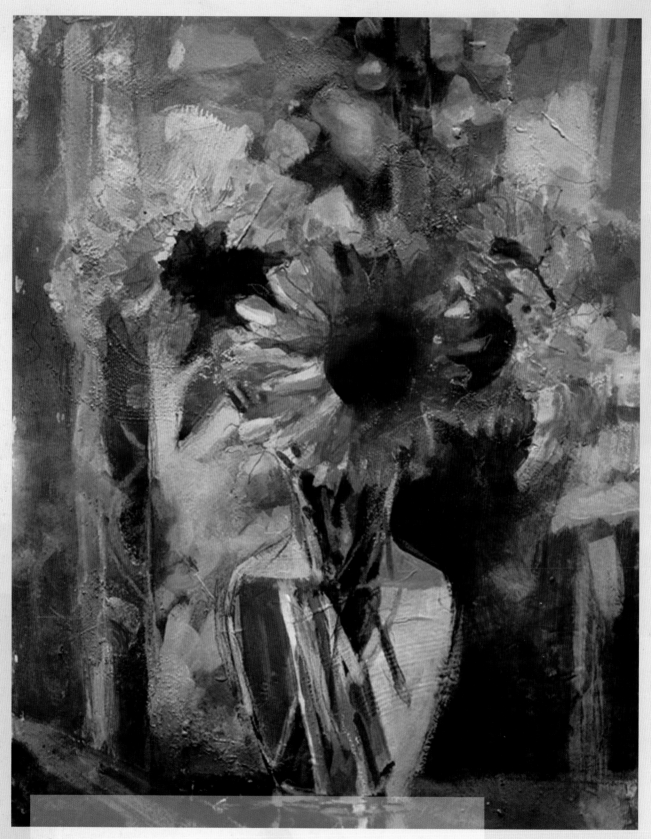

Gallery: Small Gift
20" × 16" (51cm × 41cm), mixed media on paper, private collection

Gel mediums, pumice gel and mark-making tools are part of the foundation of **Small Gift**. The result is a surface rich in variety between rough and smooth. The rough areas will catch the brush marks in a very different way than a smooth surface.

Contributing Artist: Suzanne Northcott

I use both cradled birch panels and gallery canvases. Cradled panels are great for mixed media, standing up to tough abrading, scraping and the scrubbing that image transfer requires. Once a panel has several layers of paint, I can even take an electric palm sander to it and let new patterns emerge. Gallery canvases have a pleasing responsive spring that I miss with the panels, and they are better for larger pieces when panels are too heavy.

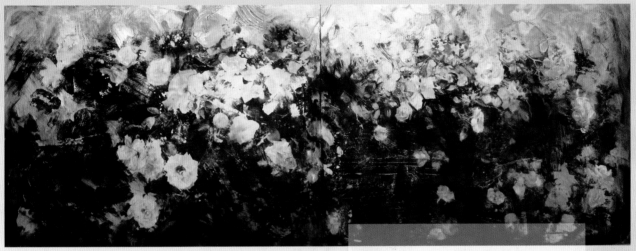

Roses & Ruin
36" × 96" (91 cm × 244cm), acrylic, photo transfer and graphite on cradled panel

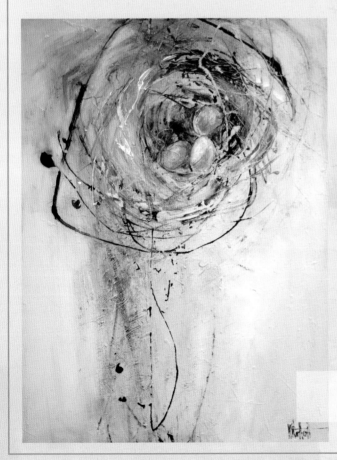

My muse is a voice or an impulse that shows me where to look, where to wonder, what to explore. A feeling of resonance, something ringing in me, alerts me to a subject or idea that wants my attention. Often it is the beauty of the natural world, a pattern or an image that catches me more than once. Less often, an image appears in my mind, fully realized, with an urgency that calls me to make it. Inspiration can come from dreams, heartbreak, insight or from other disciplines such as dance or poetry. It's as though the world is faithfully trying to hand me what I need, and I just need to know how to see that.

Moss Nest
48" × 36" (122cm × 91cm), acrylic and ink on canvas

Contributing Artist:
Colleen Philippi

I respond to each element, including the surface support. I do occasionally paint on paper, but very soon in my practice I developed a distaste for surfaces that moved. I like the solidity of the brush on wood. It gives me a sense of security and satisfaction. Weight is significant. If the work is interactive, it must be strong enough to handle without chance of damage.

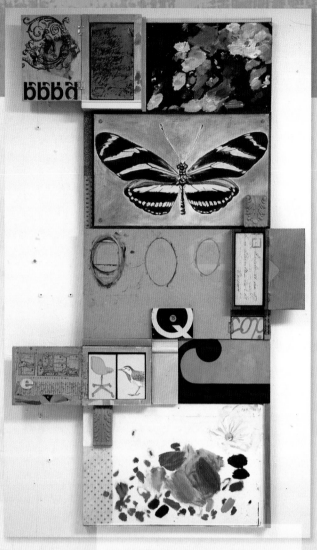

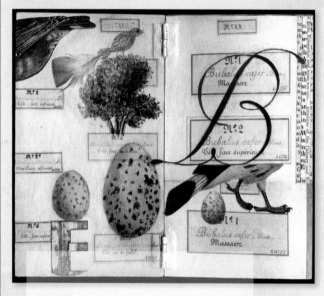

i Butterfly, B book
6" × 3½" (15cm × 9cm), 1½" (4cm) closed, paint and collage on board

The image shows the box, which holds the book, open. The inside door has a series of Bs and a D.

i Butterfly
46½" × 18" (118cm × 46cm), mixed media on wood, collection of Newzones Gallery of Contemporary Art

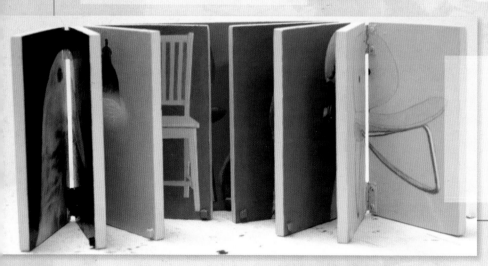

i Butterfly, Birds and Chairs
4" × 5½" × 1½" (10cm × 14cm × 4cm), oil and acrylic on board

Letterforms look like everything; everything looks like letterforms. Letters began as pictograms, after all. In the **Bird and Chair Book**, a chair looks like an N or an H and a bird looks like a chair or a lamp, which looks like an S or Z.

Contributing Artist: Polly Hammett

The quality of the surface I use is crucial, not only for the method I employ but also in the resultant image. Since the early 1970s, my work has involved controlled contrasts of value, temperature, opacity and transparency. By alternating these elements I am able to develop hard, flat surfaces with extreme contrast that define my personal style.

In the 1960s, after working traditionally, I began to experiment with various tools and papers. I found I am not a fan of plastic or textured surfaces. I love the look and feel of fine papers. In time I realized high-quality bristol drawing paper with a fine tooth was my choice. On bristol paper I am able to wipe back areas to leave a whisper of color or larger amounts by the pressure I use to wipe back glazes. In other areas I leave very thick amounts of paint. For larger work—an added bonus—it can be found in sizes up to 30" × 40" (76cm × 58cm).

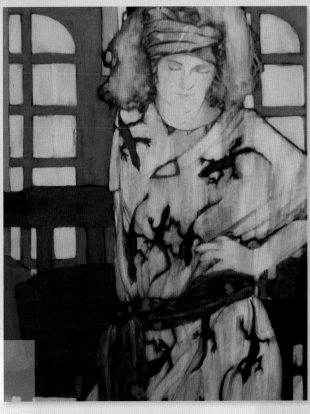

The Chameleon Dress
30" × 23" (76cm × 58cm), mixed media on canvas, private collection

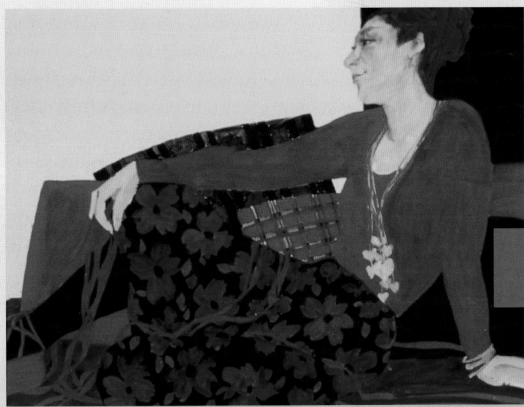

Woman in Red
23" × 30" (58cm × 76cm), mixed media on canvas, collection of Mr. and Mrs. Ken Austin

Chapter 3

Texture

Texture can be thought of in two ways: the actual physical, tactile quality of a surface or the illusion that we create when making marks on a surface. There are many ways to achieve the illusion of texture in your paintings. A few to consider include:

- Splattering—rubbing alcohol, paint or water—on a wet or dry surface
- Agitating partially dry acrylics
- Adding gravel or sand to matte medium
- Adding salt (not recommended)
- Mixing light-bodied paint with heavy-bodied paint.
- Scraping the surface of the paper (either wet or dry) with a tool

Texture plays a wonderful supporting role in painting. Because the illusion of texture is defined by value or color, it is difficult for it to have a strong main role without the painting becoming very busy. For me, texture is an auxiliary way to add interest—like icing on the cake.

As percussion in music adds richness to the song but is not the main melody, texture adds a similar interest to the visual effect. The physicality of a rough or smooth surface will affect your brush strokes and the overall visual result, so, once again, know your intention.

Let's explore some more ways that we can make marks.

Gallery: Cover Story
16" x 20" (41cm x 51cm), mixed media on paper

*Texture is a great supporting element of design. Because it is defined by either value or color, it is destined to live in the background as a secondary accoutrement. When the viewer is brought in for a closer look, the texture is waiting to offer detail and enhance the overall image. In **Cover Story**, texture becomes a very important element once the basic structure is laid in with values, shapes and colors. Building up these layers of textures is for me really enjoyable and the results are very satisfying. To see a full step-by-step demonstration of the creation of **Cover Story**, turn to page 43.*

Mark-Making

The way that you make a mark is as individual as the way you write your signature. The tools that you use become an extension of your arm just as with the paint brush.

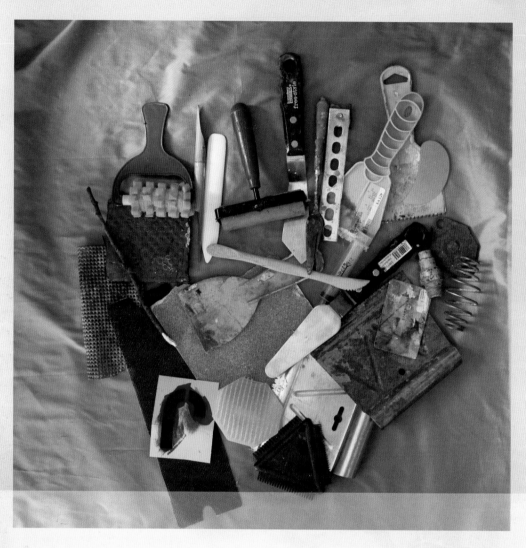

An array of tools to play with.

You can use anything that you don't mind getting paint on to make marks. I raid the garage and pick up interesting things at yard sales and hardware stores. Nothing is off limits to me with regard to tools for making marks in a painting. Once I have a pile of tools I will play around with the objects, holding them in different ways, rolling, rocking, scraping, dragging them across the wet painted surface.

Have fun. Practice making marks using the tools as stamps, using brushes loaded with paint, using sticks to make lines. Notice the variety offered with different pressures, different techniques.

Once you have experimented with the various tools at your disposal, think about where those marks might look good. What application will you use for your next landscape or still life? Would the marks be best for an abstract image or a referential one?

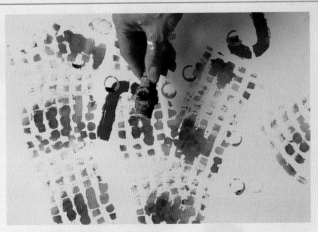

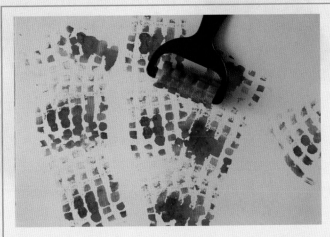

This is a roller I purchased at the local hardware store. It's interesting to see the mechanical and somewhat predictable marks it makes.

Stencils are a great tool for making marks and also for communicating ideas through their symbolism. I used J for obvious reasons! I found a nut attached to a bolt and stamped and rolled it on the paper with Teal fluid acrylics.

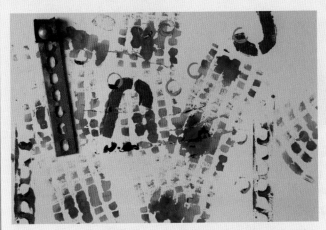

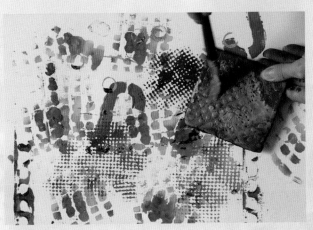

I have no idea what this is, but I found it in the garage and it makes great mechanical lines!

The foam plate from yesterday's steak dinner and a no-skid pad for the sink make great gridded dots.

I dragged this old spring through my palette and rolled it onto the surface of the paper.

Trowels and palette knives are very useful for making larger marks and shapes. In this example I applied a more viscous paint with a trowel. I then scraped back some of the paint, also with a trowel.

Tools from other disciplines are useful in painting. I have a bunch of ceramics tools that have come in handy for the wonderful marks they provide. Notice how the scraping tools expose the obscured patterns from the thick opaque paint.

Go big! Try adding more paint over patterned areas and then scrape it back with a large serrated trowel. Notice that the paint is opaque and thick.

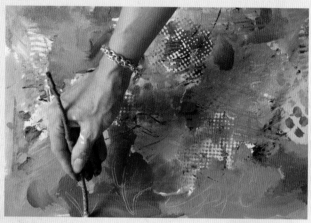

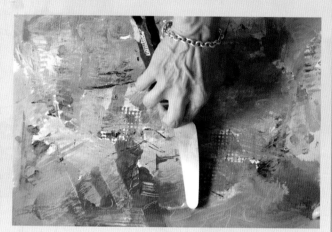

Go small! I found a stick in the garden to use for scraping in calligraphic lines.

A large palette knife is used to spread and scrape paint onto the surface.

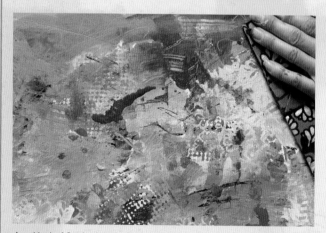

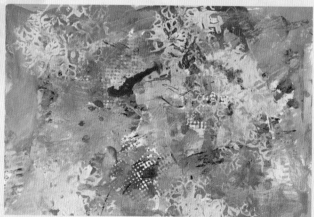

Any kind of flocked material is great for stamping patterns onto your surface. The flocking can also be used to lift paint off your surface. I used a flocked gift bag that I picked up on sale at the local bookstore.

Your finished ground might look something like this. Remember, there are no rules except to trust your intuition and have fun with the process.

Drips and Doodles Exercise

Another fun exercise—this time with drips and doodles.

What You'll Need:

- brush – I used a ½-inch (13mm) nylon brush
- colored pencil sticks
- fluid acrylics: Teal, Cobalt Blue, Quinacridone
- Magenta, Quinacridone Nickel Azo Gold
- gesso, white
- pencil
- rubbing alcohol
- support: paper, Arches 140-lb. (300gsm)
- watercolor crayons
- watercolor sticks

1 Cover dry paper with a layer of fluid colors and white gesso mixed to provide a variety of transparencies and viscosities.

2 While the paint is wet, try making marks with a watercolor crayon. Notice how the paint is pushed aside by the crayon and how much crayon pigment may be left behind. If you enjoy line as an element of design, here is an opportunity to use line in wet paint.

3 Try adding some more pigment to the surface with a watercolor stick. The width of the mark will be broad and will give you an opportunity to infuse pure pigment onto the surface. Using a brush, you may want to practice softening edges, mixing the pigment into the wet paint or eliminating unwanted marks.

4 Place more fluid acrylic and gesso mixtures on the surface to obscure and integrate the marks that you have made. Try a colored pencil stick and note the difference in the marks and in the amount of pigment that transfers to the surface compared to the water-soluble crayons and sticks. The watercolor crayons and sticks are much softer than the pencil sticks, and they tend to leave more pigment on the surface.

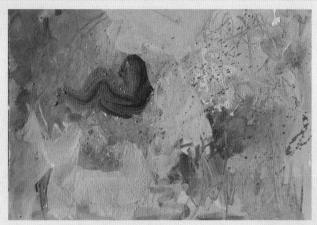

5 Continue to add your gesso and acrylic mixture in different viscosities and opacities. Don't be afraid to splatter some rubbing alcohol or paint to add diversity to your marks. This process is so much fun!

6 Add more doodles with a pencil—this time to create a variety of lines. Again I layered various semiopaque acrylics over some areas, being careful to allow some of the beautiful lines and colors to peek through subsequent layers. The surface is maturing, becoming more interesting with subtle variations to entice the viewer to look more closely.

7 The area where the paint has repelled has rubbing alcohol beneath it. This layer of acrylic paint is more transparent.

8 These applications could be used for an interesting background, specific areas in a painting like a garden, material in a person's clothing or as a great ground surface to paint on.

Wrapping Up the Concepts

Let's try a painting that incorporates the concepts from the first three chapters. I have decided to work on a paper surface. Try to integrate these concepts—transparency, opacity, viscosity, surface quality, texture—into your own style. Feel free to paint a subject entirely different from this one, should you so desire. (You'll find lots more on subject matter in Chapter 7.)

What You'll Need:

- 140-lb. (300gsm) Arches cold-pressed watercolor paper
- board (I used Gator board)
- brushes (Use different sizes and shapes of brushes; in this demo, I used ¼-inch
- (6mm) and ½-inch (13mm) flats, and 1-inch (25mm) and 1½-inch (38mm) rounds
- bulldog clips
- fluid acrylics: Teal, Quinacridone Red, Phthalo Blue Red,
- Hansa Yellow, Pyrrole Red, Diarylide Yellow
- gesso (black and white)
- paper towels
- pencil crayon (black)
- rubbing alcohol
- self-leveling gel

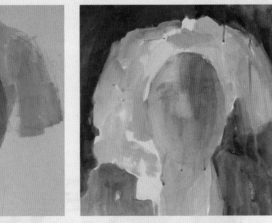 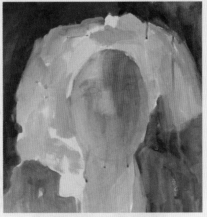 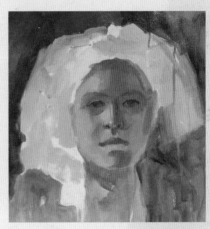

1 Use Hansa Yellow, Phthalo Blue and Quinacridone Red as the first layers of paint. Because you are using transparent acrylics, you can cover any areas with opaque paint to sharpen shapes and tweak the image as you go. You want to cover the surface with paint and should not be concerned about going over the lines. Next integrate opaque paints into the mix so the transparent and opaque wet paints can mingle. Both white and black gesso were added to my paints and then applied to the paper to punch up the opacity.

2 Continue to cover the surface with transparent and opaque mixtures of Hansa Yellow, Phthalo Blue and Quinacridone Red tinted with black gesso. Don't worry about the drips; sometimes they enrich the surface and they can always be painted out.

3 Sometimes a bit of definition is a good idea, especially if you are painting referentially. Here I loosely defined the features of the face.

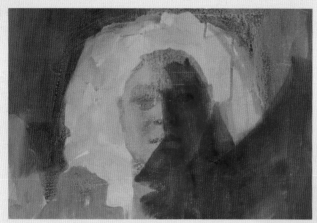

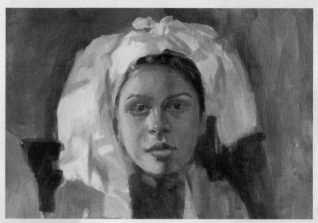

4 Sometimes a good glaze over a surface will help to unite the image. Using Pyrrole Red and Diarylide Yellow, cover the surface and then quickly grab a paper towel and wipe off the excess paint, leaving behind a warm yellow-red stain.

5 Notice how much warmer the image appears after glazing. Boost the light shapes with some opaque tinted gesso.

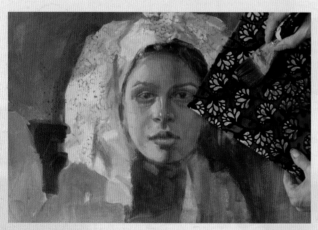

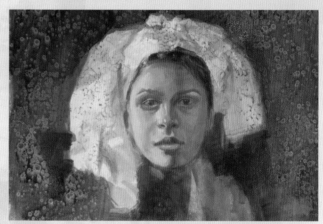

6 With your brush filled with paint, brush lightly over a piece of flocked paper and then stamp it onto the surface of the painting. I did try to hit the scarf wrapped around her head with the pattern from the paper. You have to be careful with how you use stamping and how much pattern is left. Overdoing some techniques can appear too contrived.

7 After I applied pattern to the scarf I thought … more texture! So I applied another layer of transparent paint in the background and then splattered it with rubbing alcohol.

Yikes! Good learning experience here as it is easy to see how too much of a good thing can give you a headache. Don't give up when things aren't looking visually pleasing; this is just the awkward teenage stage that you are painting through! Keep going and remember that every layer will only make the final product more interesting.

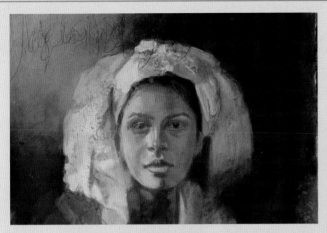

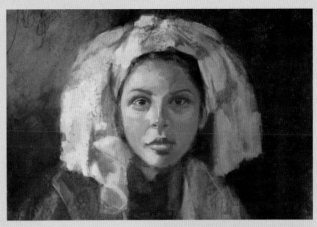

8 Use a pencil crayon and incorporate some calligraphic marks on the surface. Add a layer of self-leveling gel.

Simplify and tone down busy areas: Mix two different batches of paint to subdue the textures. Mix one to be a dark transparent and the other an opaque light paint. Use the dark paint to glaze over three-quarters of the background. This reduces the value contrast of the texture while allowing some shapes to show through. The opaque paint can be watered down a bit and applied to the top left quadrant of the background to obscure more of the textures and offer some variety. Apply additional calligraphic marks on top of the new opaque area.

9 Every step leads you to another choice and another adjustment. Tone down the value contrast of the top left corner so it does not draw so much of the viewer's attention.

More adjustments were needed within the face of the girl to both define and soften the features. I decided to glaze over parts of the right side of the face and left shoulder with some Phthalo Blue.

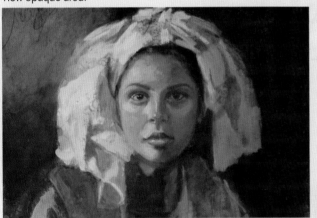

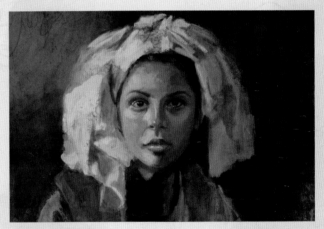

10 I felt like this portrait still wasn't quite there; there was not enough push and pull between lights and darks, warms and cools. I corrected this by glazing with Hansa Yellow, Phthalo Blue and Teal.

11 Continue glazing to darken the right side of the face and the clothing.

You have to trust your decision-making ability and push forward. Often at this stage I will stare at the painting to see what looks out of place and what feels right. In this case I felt the scarf was too similar in shape all the way around the girl's head. I went in and shifted the edges in or out to lose the dominant horseshoe shape. A few more darks were added in areas of shadows to help define shapes in the material folds.

See the finished piece on page 36.

Contributing Artist: Maxine Masterfield

Leafy Glow
Leafy Glow is made on Letramax Illustration board. Several layers of ink are poured. A few cut pieces of plastic leaves are placed over the pour. The entire surface is covered with a hologram sheet of plastic and left to dry for several days. The result produces a 3-D effect.

Enchanted Night
For this piece I pressed transmission parts into modeling paste. When the paste was dry, iridescent liquid acrylics were poured over surface. All of this was left to dry overnight.

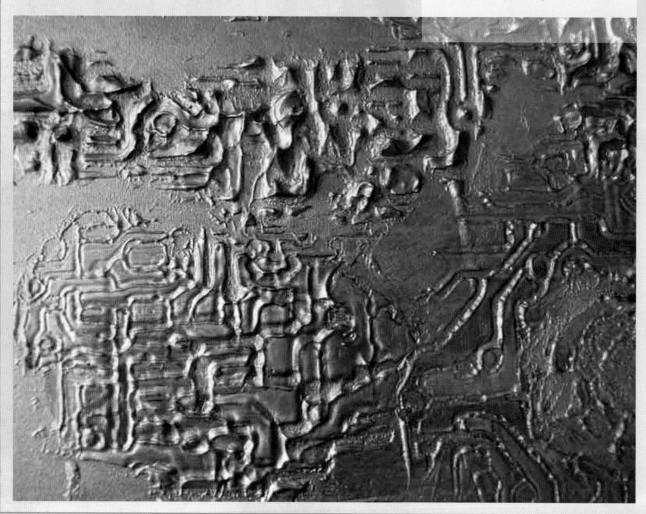

Contributing Artist: Jeremy Mayne

I use different textures to call to mind a viewer's memories of the sense of touch. We all have feelings tied to experiences in life where the sense of touch played a role.

Myth of Empire
18" × 15" (45cm × 37cm), watercolor monotype, acrylic paint, collage, graphite, colored pencil, lacquer print on handmade paper

Myth of Night
20" × 15" (51cm × 37cm), watercolor monotype, gold leaf, chalk pastel, graphite, colored pencil, charcoal, lacquer print on BFK Rives paper

Sandstorm in Eden
13" × 21" (34cm × 53cm), watercolor monotype, torn paper, collage, chalk pastel, colored pencil, lacquer print, sanding, acrylic paint on Stonehenge paper

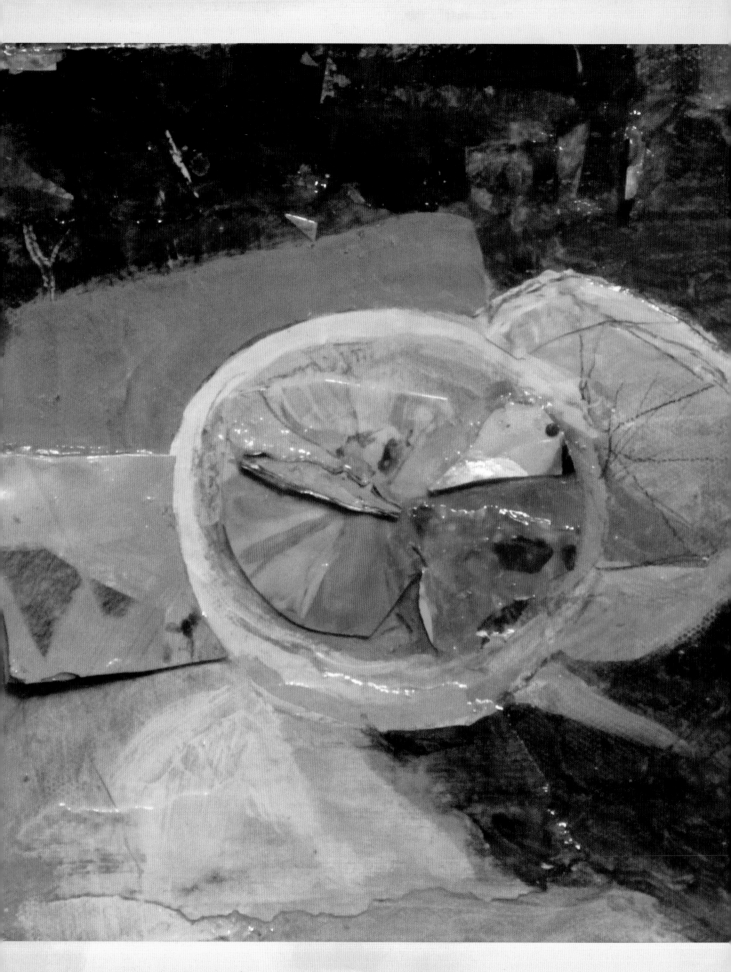

Chapter 4
Collage

Collage means to glue. Collage is the technique of gluing items onto the surface of a painting to create relief, pattern, color and value.

The technique of collage has a long history dating back to the invention of paper in China and was used in Europe in the fifteenth and sixteenth centuries. Gold leaf, gemstones and precious metals were applied to religious images and heraldic crests, and even manuscripts were illuminated with gold leaf.

An extraordinary early work incorporating collage is *Las Bodas de Cana* by Nicholas Correa (Mexico, 1693), which now hangs in the Hispanic Museum in Harlem in New York City. The painting is done in oil on panel and is encrusted with mother-of-pearl.

As artists, we have an historical precedent for using whatever materials are at hand to create the best image to reflect our intentions. Collaging different items—such as paper, found objects or photographs—offers richness of surface quality. The collaged item can provide a surprise for the viewer in transparency, pattern, relief, edging, texture, color and value. The collaged item may also give the image meaning through symbols, as in iconography.

The collaged item should feel like it belongs in the painting and in the composition. Integrate your items into the painting by considering all elements of design. When you use collage, think of the object as you would think of paint. Whether we paint it or glue it onto the surface is irrelevant as long as it works in the composition.

Your intention is important because it will influence your collage options. For example, do you want to use only paper, and if only paper, will it be handmade, or will you use manufactured paper from the art supply store? Will you use transparent or opaque paper? Are there certain colors you want to work with? Knowing your intention will help you start looking for those items in your daily travels.

Found objects may be paper, wood, rocks, glass, nails, linoleum scraps, parts of electronics, even dried acrylic skins from your paint palette—anything you find interesting can make a good addition to your composition.

Leafing or gilding is another collage material with its own techniques for application.

Gallery: *Lemon Dressing*
8" x 10" (20cm x 25cm), mixed media on paper, private collection

Lemon Dressing *began on a surface that already had collage and some paint on it. I drew the composition on the surface, then negatively and positively painted the lemons. I wanted to push it further, so I cut shapes from chunks of dried acrylic and created shapes appropriate for the painting and collaged them in.*

Collage Using Different Qualities of Paper

In this demonstration you will use different qualities of paper—heavy, light, thick, thin, transparent and opaque—to collage onto a surface. The adhesive you choose should match the paper; for example, a thin tissue-like paper needs a thin medium or glue, while a heavier paper requires a thicker, heavy-bodied glue. How the adhesive is applied also depends somewhat on the weight of the paper being collaged.

What You'll Need:

- brayer
- collage papers and ephemera
- gel medium
- matte medium
- paintbrushes
- palette knife
- vellum, frosted
- wax paper
- white tissue paper

Paper samples: Handmade papers come in a variety of weights and transparencies.

Paper samples: Designs have been mechanically printed on these papers.

Paper samples from most transparent to most opaque: colored tissue, frosted vellum with handpainting, white tissue, manufactured collage paper, 140-lb. (300gsm) watercolor paper painted with watercolor.

Use a heavy-bodied gel with thick or heavy collage items. This manufactured paper is substantial in weight and requires a heavy gel.

1 Apply the gel to the backside of the paper with a palette knife or with your finger.

2 Flip the collage paper over and place the gel side down. Place wax paper over the collage paper and use the brayer to apply pressure and roll over the collage piece to even out the gel, achieving a flat surface.

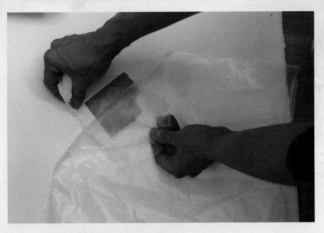

3 Remove the wax paper and wipe any excess gel from around the edges of the collaged paper.

4 Experiment with where to place the next piece of collage paper. This piece is watercolor paper painted with watercolor.

5 Brush gel medium to the back of the collage piece and then apply the collage piece to your support.

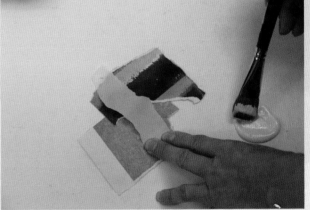

6 Try a semitransparent paper next. This is a lighter-weight paper, so use a lighter-weight medium. I used matte medium. Follow the same collaging process.

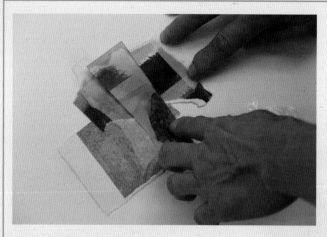

7 For variety, try placing some frosted vellum.

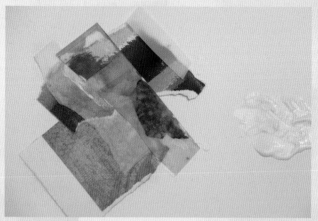

8 Keep building your collage by adding more papers. See how transparent papers look different once they are glued down?

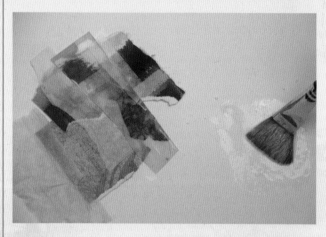

9 The colored tissue is thin and delicate; thin your medium with a bit of water.

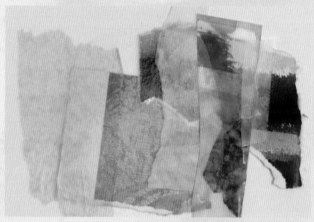

10 Once you have built as many layers as desired, place wax paper over the top of your collage and place a heavy weight (like a book) on top. Leave the collage to dry. Weighing it down should ensure a flat collage.

Collage Exercise

Challenge yourself with these simple collages. The exercise is to encourage you to play with balance and to make pleasing compositions.

Start with blank paper as your surface, and then select papers with different colors and patterns. You can use your own paper or manufactured paper. Because I was developing fifty collages, I used mainly purchased paper.

This exercise requires a lot of thought about all the elements of design: size, shape, value, color and texture. We'll explore more about composition in Chapter 8, but for now, just practice placing the shapes and colors until it feels right. Our brains really do see balance and what is pleasing or not pleasing.

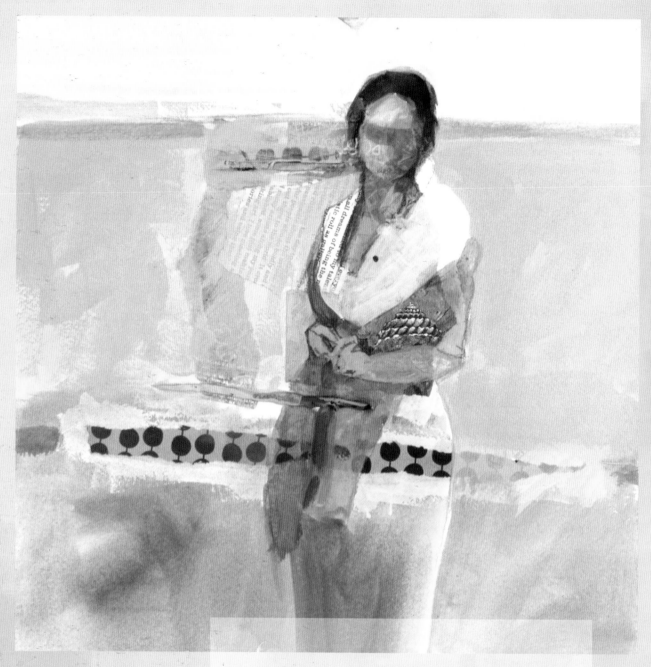

Gallery: A Myriad of Choices
10" × 10" (25cm × 25cm), mixed media on paper

I developed a series of fifty collages, and some evolved into representational images. This is one of the fifty. In a sketchbook I drew many poses in a simplified way, eliminating detail but keeping proportions, angles and gestures authentic. Later I redrew some of those figures on top of the collages and I played with positive and negative painting, obscuring and emphasizing different areas to get a good design. My intention was to balance shapes, colors, darks and lights in a pleasing manner. I was not concerned with form or source of light.

Found Objects

Found objects add not only interest to the composition but also relief to the surface. Think about the kinds of objects that attract you. Do some objects have meaning for you? Do they relate to each other in a theme? Can you use these objects to help tell your story?

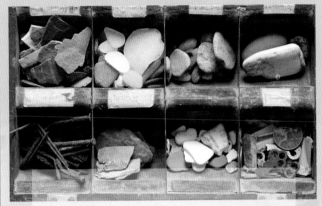

This beautiful old box holds objects that surely will find their way into a future painting. The rocks, beach glass, pottery shards, keys and old coins were all collected during a trip to Canada's east coast.

More found objects including old photos, an old ledger and a rusty hinge, all of which will surely find their way into my work.

Conservation considerations when using found objects?

If I chose to embed a rusty nail into an acrylic surface, I would use a heavy gel. This not only adheres it but also helps to create a barrier to protect the painting.

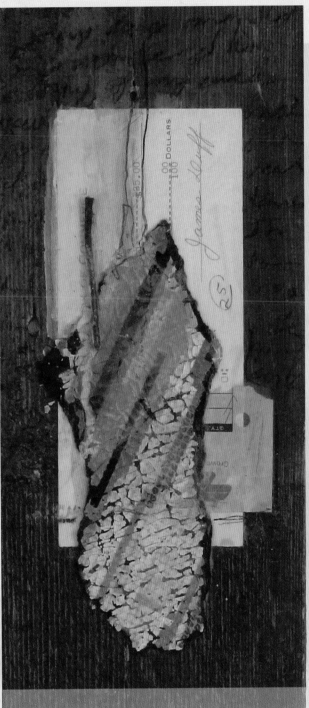

Gallery: Payable in Writing
16" × 5" (41cm × 13cm), mixed media on board

For the **Farm Fragments** series, I harvested a number of items from both of my grandfathers' old homesteads. Shingles, frames from windows and doors, paint peeling off walls and ceilings, linoleum, nails, photographs, receipts and documents—all these fit within the theme of the decay of the social fabric of the prairies.

In this piece I also used pencil crayon to write script in the background. These shingle collages are a lovely way to compose beautiful imagery using fragments of the past.

Leafing and Gilding

Leafing or gilding is the technique of applying thin sheets of metal leaf to a surface.

Faux metals are aluminum-based and available in different colors. Faux metal leaf is more brassy than its genuine counterpart but also much less expensive and not as thin, so it is easier to handle.

The process for leafing begins with brushing glue on a surface, allowing it to become tacky and then applying the leafing to the tacky glue. There are two kinds of glue: One is oil-based and takes twenty-four hours to get tacky; the other is acrylic-based and gets tacky in about an hour. After the leafing is applied, a soft brush removes the excess gold to reveal the shape.

In these demonstrations you'll learn how to apply leafing to two prepared surfaces, pliable to rigid, each with a different surface quality. You'll also explore techniques for putting glue down to achieve different patterns, marks and textures in your painting.

Leafing materials include:
Right side: faux metals, pure copper leaf, variegated metal leafing sheets. Left side: 23- and 24-kt gold, sterling silver, old world glue, a soft brush for removing loose leafing and a more rugged brush for applying the glue.

Surfaces for leafing include:
Three different surfaces appropriate for leafing: paper with paint and texture, painted canvas, board with paint and texture.

Working with leafing

I buy gold leaf in a package of 25 that has the gold leaf floated loosely between sheets of paper. When I apply the gold leaf, I do not use a gilding point, which is the traditional tool. I transfer the leaf directly from the package to the surface because I have better control. I could lift the leaf out of the package, but it likely would tear. Instead, I flip the whole package over with part of the paper folded back and place the exposed leaf down onto the tacky glue. When I lift it up, the leaf will tear along the fold ridge. To continue, I fold back a little more paper to expose more leaf and again place the leaf down on the tacky glue. This process works for me; you'll have to figure out which technique works for you and incorporate that into your process.

Both faux and genuine leaf are fragile, but the aluminum-based faux leaf is slightly less flimsy, so you have a better chance of picking it up and moving it about.

I also put a bit of soap in the brush before applying the glue. This helps remove excess glue afterward, but you can use just soap and water or a brush cleaner to clean your brushes as well.

I use an acrylic-based glue if I plan to continue with acrylic-based products.

Leafing on Painted and Textured Board

What You'll Need:

- glue for leafing (I used an acrylic-based glue.)
- leafing (I used faux in this demonstration.)
- mark-making tools
- masking tape
- prepared surface
- soft brush

1 Choose a prepared board. Using masking tape, mask off structured and/or organic shapes. Apply glue inside the masked areas.

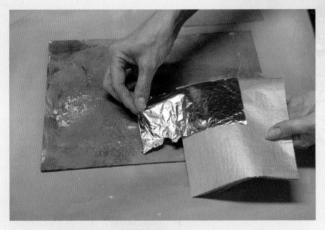

2 Wait about an hour for the glue to get tacky. Then place the leafing facedown on the glue. You can see here that faux leaf is a bit easier to handle than real gold.

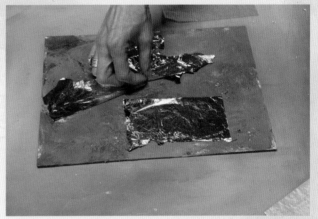

3 Continue adding leaf as desired to the glued areas. At this point you may also want to try making marks with the leaf. For example, try scraping into the wet glue to remove some of it and create ridges.

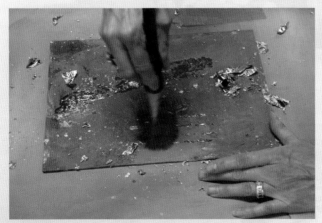

4 Use a soft brush to brush away the residual leafing.

5 After leaf is applied, use a soft brush to clear away loose leafing. The leaf will have adhered to the pattern of the glue.

Leafing on Prepared Canvas

1 Choose a prepared canvas. Apply a bit of glue in a random organic shape. Then, using masking tape, make some structured geometric shapes. Apply glue inside the masking.

2 Remove the tape before the glue dries. Pull the tape away at an angle to ensure crisp, neat edges.

3 Designs in the wet glue impact the way the gold leaf sits on the glue. For example, try scraping into the wet glue to create ridges.

4 Apply leaf to the glue. Note how you can handle faux leaf; real gold would rip.

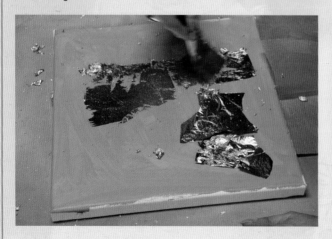

5 After leaf is applied, use a soft brush to clear away loose leafing.

Gallery: Nesting
10" × 10" (25cm × 25cm), mixed media on board

*Metal leafing of any kind can overwhelm an image. The shiny
nature of metal demands attention, so you have to be thoughtful
in using leafing within a painting. I use a lot of real gold when
gilding as 22K and 23K are not as glitzy as man-made versions.
In **Nesting**, platinum gold leaf is used as an accent to enhance
the composition and to act as a metaphor for the gifts we find in
the simple things in life.*

Contributing Artist: Brian Atyeo

The use of collage has fascinated me since I first saw Picasso's and Braque's use of paper and found objects, but it wasn't until I saw Romare Beardon's collage that I saw the possibility of involving myself in this thinking.

I use collage in one of two ways. The first is layering paper and paint to a point where I might have ten to fifteen layers. I then use pliers to pull off dried collage pieces (paper) and expose what amounts to a random presentation of paint and collage. It is from this visual reveal that I continue to build the painting. This process can repeat many times in the development of a painting.

The second technique involves introducing collage (painted paper) to an acrylic painting at various stages. I use collage in this way to "disturb" the field of paint, and unity is achieved through fine-tuning the back and forth of paint versus collage. When adding collage in this manner, I make sure that the collage has a dramatic effect—either tonally or through intense color. This forces me to see the composition and painting in a totally new way.

Quota 32
36" × 20" (91cm × 51cm) collage and watermedia

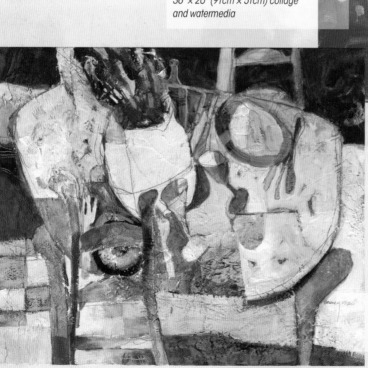

Brunch
24" × 30" (61cm × 76cm), collage and watermedia

Contributing Artist: Katherine Chang Liu

Not having taken art classes from schools or workshops, collage was an instinctive component of my work from the very beginning because it provides me with a process to create what I want in my work.

I do not use commercially manufactured decorative rice paper and such for collage, because the source makes the work predictable and calls too much attention to the "art supply."

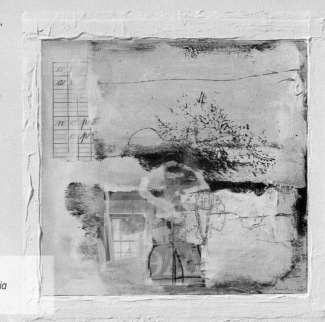

All Things Mutable #3
15" × 15" (38cm × 38cm), mixed media on panel, collection of Deborah Pines

Litmus Series #1
10" × 16" (25cm × 41cm), mixed media on panel, collection of Ellen and Bob Chadwick

Chapter 5
Obscuring and Embedding

Obscuring is the technique of reducing the clarity/sharpness of an area to reduce visual interest in that area or to achieve a specific visual goal within your painting. An image that has been obscured will appear indistinct or partially concealed. Obscured images communicate softness, uncertainty, perhaps even mystery.

Obscuring can be advantageous to your paintings. You can keep the general shapes, values and colors in an area of your painting but reduce the importance of the area through obscuring. Obscuring can help neutralize color intensity and value contrast or soften an edge.

As artists, we have several options for reducing the visual importance of an area:

- Glaze over the area with a transparent pigment; more layers of glazing give greater obscuring.
- Apply a medium over the area; a thicker medium gives greater obscuring.
- Collage over the area; more opaque collaged items give greater obscuring.

Papers with images on them are layered beginning with an old photo on the bottom, followed by painted vellums and Mylar sheets to illustrate obscuring of the bottommost layers.

Gallery: Homestead
12" × 12" (30cm × 30cm), mixed media on paper

When people work on the land there is a mark making that occurs; anyone who has flown over prairie fields has seen the scoring resulting from the farmers' toil. Scraping the surface of my painting to expose subsequent layers is in many ways the process of the farmers' machinery to the land. My opaque paints cover or obscure the under painting until my marks scrape through to show signs of what was. The collage is kind of like the seeds in a crop that are planted and covered or embedded in the soil and then as they grow they emerge from the substrate as a mature ground.

Obscuring

In this demonstration you will practice obscuring part of an image using tinted gel.

What You'll Need:

- fluid acrylics (to tint the gel)
- heavy gel (I used matte finish.)
- prepared surface (So that you have color value, etc. to obscure or embed.
- I used a surface created for an earlier demonstration.)
- tools to apply gel to surface (I used a wide scraper and a palette knife.)

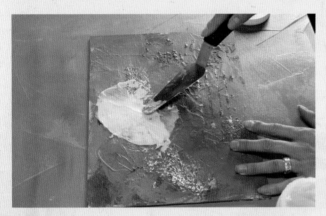

1 Choose an area of your surface that you want to make less important. On my surface I want to reduce the importance of the gold leaf and colors.

 Using a palette knife, apply heavy gel to the area. The gel dries transparent, and the gel thickness will determine the amount of obscuring that occurs.

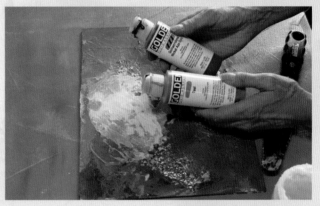

2 Try tinting heavy gel for a different result. I chose Teal and Quinacridone Gold fluid acrylics to tint the gel and mimic the look of natural beeswax. Of course, nothing really takes the place of encaustics, but using acrylics in this way will certainly provide a similar feeling. Use a large palette knife to mix the fluid acrylics into the gel.

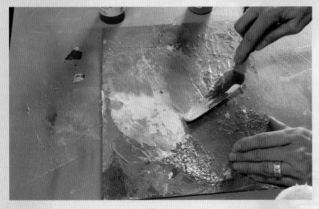

3 With a palette knife, apply the tinted gel to the surface next to the clear gel. On my surface both are still wet and demonstrate their obscuring effects on the underpainting. The tinted gel in particular has a waxlike appearance.

4 As the gels dry and become more transparent, the underpainting, while obscured, will still show through.

Vellum Obscuring Examples

In each of these examples frosted vellum reduces or diminishes the importance of the underpainting.

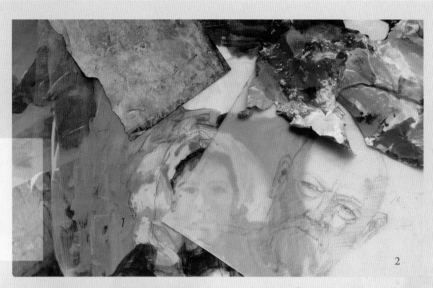

Transparent Mylar (1): Notice how the unpainted areas allow the under layers to show through.
Vellum (2) creates a veil over the underpainting to decrease its importance.

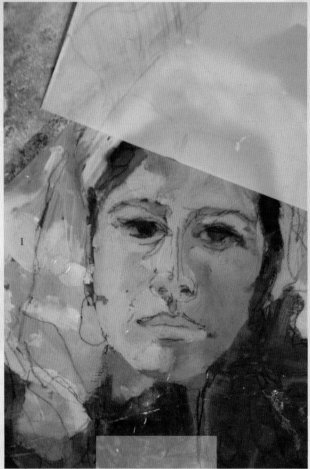

Pencil sketch on vellum placed over acrylic painting. Note how the colors and shapes are obscured. The obscured elements add interest but allow other areas to become more prominent.

Vellum placed over painted Mylar.

Using Obscuring in a Finished Painting

I have created a number of small abstract sketches—designs for future consideration as larger images. Sometimes these images are painted as abstracts, and some become foundations or grounds for a different subject altogether.

What You'll Need:

- black pencil
- cradled board
- fluid acrylics: Quinacridone Gold, Quinacridone Magenta, Phthalo Red Blue
- gesso, black and white
- paintbrushes of your choosing

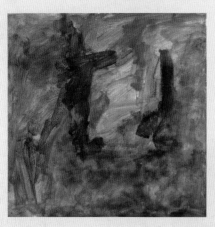

1 Using your own abstract sketch, reproduce the general shapes on a larger cradled board using fluid acrylics. With a brush, apply a bit of Quinacridone Gold and then mix a little Quinacridone Magenta and Phthalo Blue and brush on these darker values. Play with different viscosities.

2 Continue to pull out shapes by adding more layers of tinted and thinned gesso, getting a little closer to your original sketch. You can still see original gold through a veil of gesso.

3 Using your own abstract sketch, reproduce the general shapes on a larger board using fluid acrylics. Apply a bit of Quinacridone Gold and then mix a little Quinacridone Magenta and Phthalo Blue and brush on these darker values. Play with different viscosities.

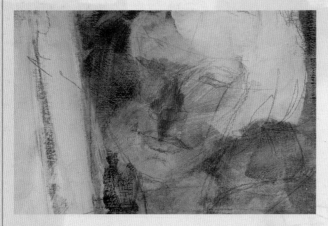

4 Sketch into the painting with a black pencil. Draw your image and then use positive and negative painting to start pulling out shapes.

I have decided (no surprise!) to paint a face on top of my abstract design.

5 Here is a close-up of the first part of the process. Notice you can still see the initial values, colors and shapes in and around the face.

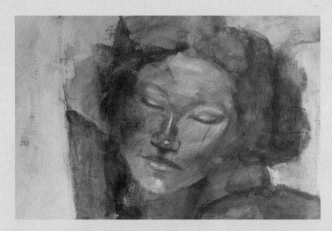

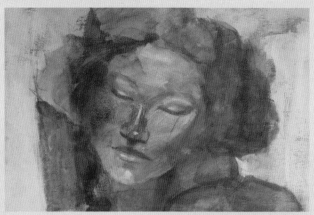

6 Brush on some darker values to establish the jawline and hair shape on the left side of the painting and a darker value to define the shape of the right side of the head and shoulder. Stay with the same simple palette, using gesso as your white or black. Try not to use too much opaque paint yet; you want to take advantage of revealing the underpainting in places.

7 Define the features in the face and obscure areas that are taking on too much importance. Use tinted gesso to bring out the shapes of the eyes, highlighting the lower lip, nose, eyelids and brow bone. Mix black, white and all three basic colors to produce a warm medium dark for the eyelashes, nose and mouth.

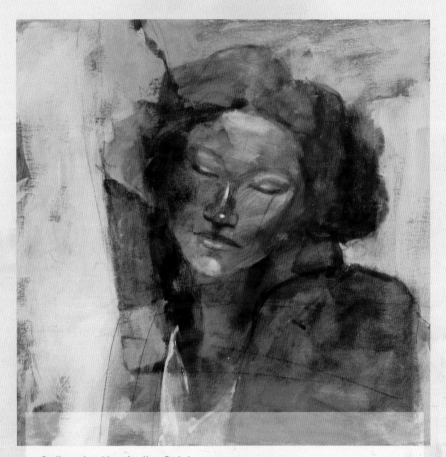

Gallery: Looking for the Quiet
12" × 12" (30cm × 30cm), mixed media on cradled board, collection of Mr. L. Bogdon

Examine your painting. I felt the dark shape to the left of the face was too strong and held too much importance. Where this occurs, layer a thin mixture of tinted white gesso over a large portion of the shape to shift the emphasis towards the face. The result is less value contrast beside the outside white area and a softening of the line made between the straight dark and light shape. As a final touch, try adding a few small calligraphic lines to emphasize edges such as the edge of the V-neck.

Obscured Collage

In this demonstration you'll practice drawing and painting an image superimposed over a collaged support, integrating mixed media into an image. Instead of a completely covered surface our surface is only partially covered with lots of blank space within the original design of the collage. It is important that you look at the surface as a blank surface with nothing on it and draw your image over what is there despite the collage. Resist the temptation to see referential imagery in the collaged pieces.

What You'll Need:

- collage paper
- collaged surface
- fluid acrylics: Quinacridone Gold, Quinacridone Magenta, Phthalo Blue,
- matte medium
- pencil
- pencil crayon, black
- paintbrushes appropriate for your chosen
- paints and mediums

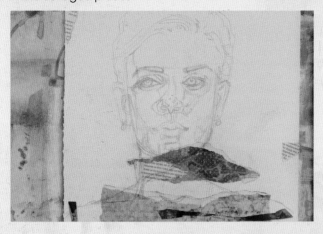

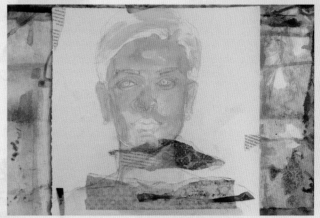

1 Go back to your previous collage exercises and choose one of them as your surface.

Choose a subject and draw your image with a pencil. Consider what your priority is in regards to the elements of design. My priority here is value and source of light in creating form. Thus, I draw in all my light, middle and dark shapes. Remember to draw through the collage pieces as though they are not there.

2 Start with a transparent paint. You can thin it with a bit of water and matte medium if necessary.

Brush on layers of gold, blue and magenta in different combinations throughout the image. Add tinted gesso to areas where there are highlights.

Use opacity to diminish areas of the collage that might overpower the structure and value of your subject.

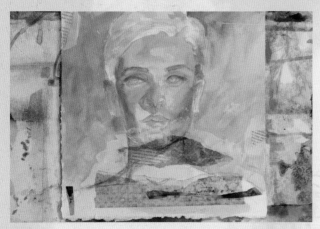

3 Continue adding layers of transparent and opaque paint until you achieve your desired results.

A note about paint layering

Think about the qualities of the paint when layering. If you are using transparent paint to achieve stronger color or value, then you'll have to use lots of layers. An opaque paint will yield stronger color and value but will appear flat and will not have the subtlety of the shifting colors of transparent layers. Matte medium will accept paint differently than your original surface accepts paint.

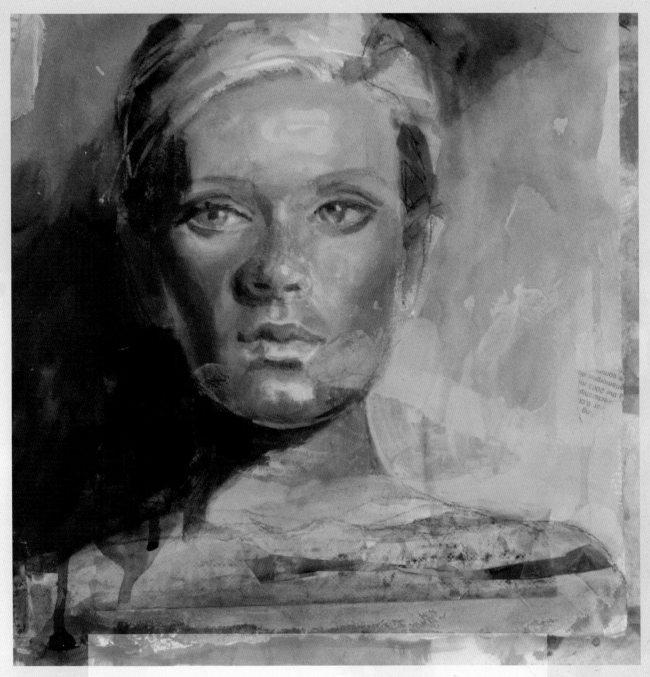

Gallery: Behind the Eyes
11″ × 11″ (28cm × 28cm), collage and acrylic on cradled board, collection of Mr. L. Bogdon

Use your opaque paint to push around your lights and darks. Here I added a veil of semi-opaque tinted white gesso on the right side of the face and some black tinted gesso on the left. My intention was to create form, so I continued to build colors and value to achieve this look.

You can also use a black pencil crayon to infuse line into the imagery. Or, while the paint is still wet, try scraping some of it away to create variations of line and value.

When you use a combination of collaged pieces, mediums and paint, the result is an uneven surface with one medium accepting paint differently than another medium. These imperfections appeal to me because the result is a richer surface.

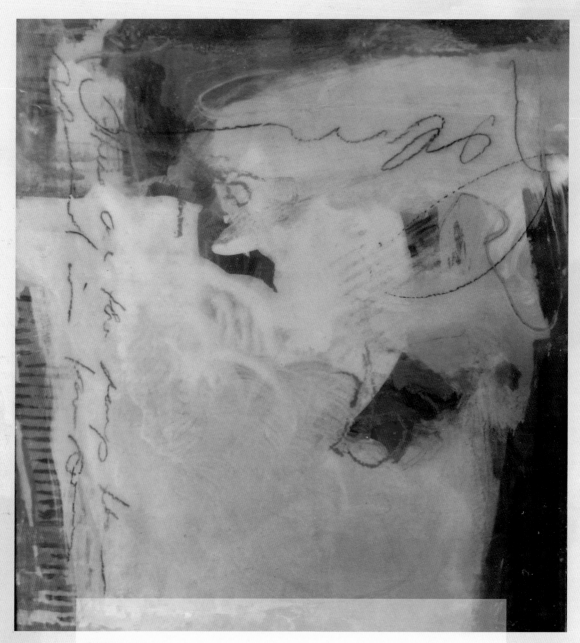

Gallery: Letters
10" × 10" (25cm × 25cm), mixed media on board

This painting began with acrylics and gels. With a pencil crayon and a watercolor crayon I wrote some notations over the paint. A final layer of encaustics further obscured some areas of the painting.

Some encaustic artists discourage the use of wax over acrylics while others say that anything goes. I love the look of encaustics and have used wax as a final layer over small acrylic works that have shown no signs of separation after several years.

Embedding

Embedding is the technique of incorporating items and objects in a painting by enclosing them in a supporting substance. Embedding integrates items and objects into a painting by enclosing them firmly in acrylic medium. In this demonstration you will learn to embed objects into your surface using heavy gel medium.

What You'll Need:

- heavy gel medium
- objects for embedding
- painted surface of your choice
- spatula

1 Choose a surface to work on. Things to consider are how simple or complex the painted design is, the theme of the painting and the texture.

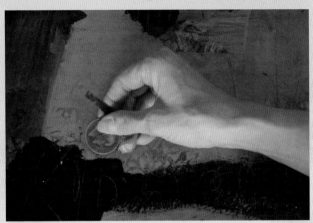

2 Choose objects that you would like to embed onto the surface of the painting. Embedding supports items that have a bit of weight and/or relief. I chose an old coin and a key collected during my summer holiday.

3 Play around with the placement of your objects and try to find that sweet spot! I will embed both objects close together; I like the way they play off each other. The more weight or thickness (relief) your object has, the greater the need for a heavy or extra-heavy gel medium. You can see the thickness of my gel as I scoop it out of the container.

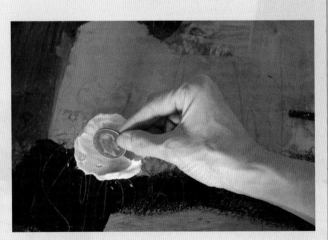

4 Spread the gel over the surface where you would like to embed your objects. Place your objects in the gel and press firmly.

5 I added my key to the same gelled area as the coin.

6 Use your finger or a tool such as a spatula to smooth out the gel. If you don't want a high ridge outlining your object, taper the thickness of the gel, gradually thinning away from the item.

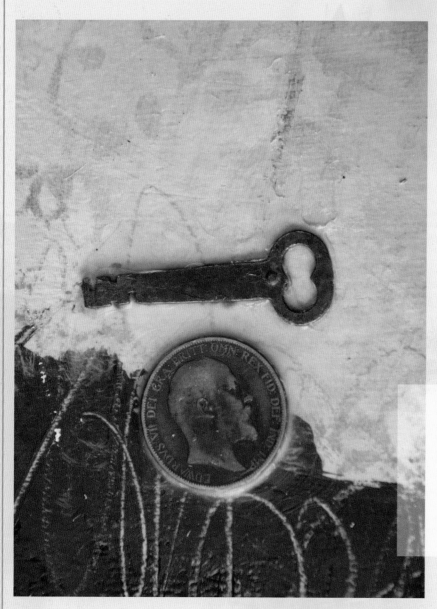

While the gel medium is wet, there's no need to worry about the cloudiness. The thin areas will become more transparent as they dry. Note that the top surfaces of the coin and key are showing raw metal. It is your choice to entirely submerge and encase your items or leave some areas raw.

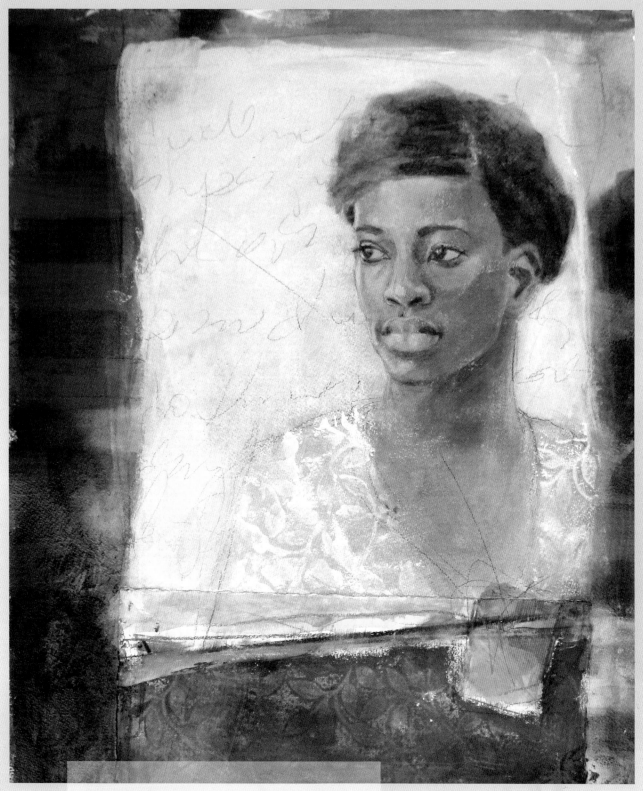

Gallery: Layers in Time
20" × 16" (51cm × 41cm), mixed media on board, private collection

Allowing some colors, marks or text to show through subsequent layers results in a very rich, mature surface. Each new layer of paint slowly obscures those beneath; much like our memories, they aren't as sharp or clear over time. The painting process can really help express the passing of time and support the content of the painting.

Contributing Artist: Mark Holliday

What seems unquestionably appealing about encaustic painting is the physicality of the wax surface coexisting with forms of illusion. The more the wax medium reveals itself as a colored organic substance, true unto itself, the more it seems to define the real.

Study for Landscape 018
encaustic and oil

As beeswax is loaded hot on to the paintbrush, it cools and hardens within seconds of application. This makes details hard to perfect. Generally the hot wax application is a one-shot deal and much thought may be required between brushstrokes. Over time I have learned to let the wax just do its thing. Erroneous dripping and splashing on the painting will happen as you move the hot brush over and around the work. Removing wax from multiple layers later, if it is not to my liking, often produces marks and shapes that cannot be invented during the painting process. However, to help overcome the difficulty of dealing with detail, I will often use a digital image encapsulated within the work.

Study for Large Painting
encaustic and oil

With some planning I will print a photographic image at the required scale on basic white paper. Then, using a flat-based hot iron, I will fuse the paper to the first layer of wax of the painting with little or no wrinkling. Further painting may obscure the photo/image, but the beauty of the printed image is that it is quite resilient. The wax can be removed and the image reworked several times without harm until it marries with the painting. It is also an efficient way to create several small playful studies of the same subject.

Contributing Artist: Elise Wagner

Apex 1
24" × 72" (61cm × 183cm), encaustic and oil on panel, courtesy Butters Gallery, Portland Oregon)

Encaustic offered a quick drying time, adhesion and the depth of layers I was seeking for my work. As the oldest-known pigment binder, encaustic is inherently a preservative with historic proof of artwork still existing in funerary portraits from as far back as 23 b.c. With encaustic, I also discovered that I did not have to abandon my oil paints entirely. I paint with oil paint and oil bar over the encaustic in the top layers. The oils dry faster and absorb well into the wax, which allows me to further exploit the texture of encaustic and enhance the rich depth and atmosphere common to my work.

Transit Horizon 2
10" × 10" (25cm × 25cm), monotype, encaustic and oil on panel, courtesy Butters Gallery, Portland, Oregon

I think my preoccupation with attempting depth and a window into my work has always been the most exciting aspect of making the work. I am compelled by the idea of laying down a foundation to build upon, bury, scrape back into or reveal. Burying and embedding provide one's own personal creative system of navigation to reveal what you like and cover up what you do not. I originally began embedding with sewing patterns. I was attracted to the natural golden translucence of the paper, and also the black lines of their patterns provided a random compositional order to both begin from and refer back to in my subsequent layers.

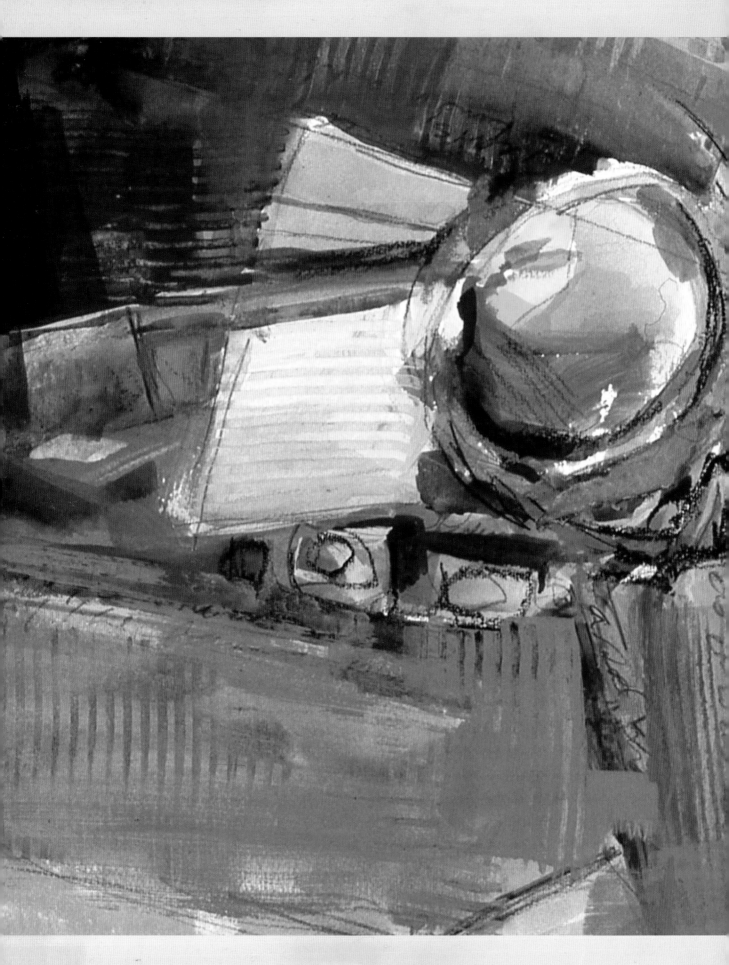

Chapter 6

Shapes: Structural Versus Organic

As artists, we use symbols to communicate our thoughts and feelings to the viewer. Organic shapes tend to read as peaceful (think of ripples on the surface of a lake), calm (think of rolling hills), nonthreatening (think of most floral shapes). By contrast, structural or geometric shapes communicate hard (think of a block of cement), sharp (think of a knife), dynamic movement (think of a saw blade or a lion's teeth).

Understanding shapes and what they communicate is part of our language as artists. Shapes may also be described as either structural/geometric or organic/fluid. Simplified, structural/geometric shapes are those with angles while fluid/organic shapes are those with curves.

When we think of structure, we think of order, strength, solid shapes and geometry. We often associate these shapes with man-made structures although they also occur in nature (think of crystals). Geometric shapes are subject to mathematical equations. Think of circles, squares, triangles and rectangles. For great examples of structural/geometric paintings, check out the work of Kurt Schwitters and Kazimir Malevich.

Organic shapes can be flowing and curvy with a variety of edges, and make us feel calm, whimsical, or fun. Organic shapes are usually associated with nature, such as clouds, an amoeba and water. Organic shapes are void of sharp edges and angles. Think of pouring paint onto a surface and allowing it to move on its own. This creates organic/fluid shapes. What kind of organic brush marks can you make?

Study these artists for examples of organic/fluid painting: Charles Strong, Jackson Pollock and Irene Neal.

Gallery: The Nest
11" x 10½" (28cm x 27cm), mixed media and collage on rag paper

I superimposed an image of a nest from my grandfather's homestead onto an abstract design. I wanted to give the feeling of furrows in the fields left by plows or swathers and the shapes formed by roads, buildings and natural anomalies as a background to the simple shape of the nest and its surroundings. Lost and found edges reduce the importance of the geometric shapes. The structure provides dynamic movement for the viewer to follow.

Examples of structural/geometric vs. organic/fluid

Organic shapes will communicate something different from geometric or structural shapes. Understanding how our mark-making impacts the viewer is helpful in having our story understood.

　　To focus on the concepts, these examples are shown with black lines or shapes on white paper.

How does this curly line make you feel? A simple curvy line has the ability to communicate a feeling to the viewer; that is powerful! We are communicating ideas when we make marks in our paintings.

Calm, rippling lines may evoke feelings of stillness, a feeling of well-being. Communicating feelings through a gentle curved line is simple and powerful.

Organic, loosely drawn flowers are symbols recognized by everyone. They evoke a sense of being carefree, happy and perhaps even goofy.

Blocks seem more rigid, more masculine, and may convey ideas such as harsh, cold, definitive and logical.

This line has action and energy. It may convey aggression and is associated with sharp things that cause injury, such as a saw blade or teeth.

This simple sketch also may evoke a sense of fear. Like the saw blade, the teeth feel threatening. The cadence of the line changed from mechanical in the saw blade to now communicating "teeth" associated with a predator.

A triangle is structural/geometric and the kidney bean is an organic shape. Does one have dominance over the other? Which one draws your attention first and more consistently than the other? My experience is that geometric shapes draw the eye more than organic shapes do.

How will you lead your viewer's eye?

Structural or geometric shapes are dominant over organic shapes, and this can be helpful when leading the viewer's eye through your composition. You can create visual tension if you use a little bit of one shape and a lot of another shape.

All geometric shapes are not equal; in fact, there is a hierarchy of perception and attention to these shapes. This example shows a square, triangle and circle—which one do you tend to look at or focus on more than others?

Which line has dominance? What do you look at first? Even though the curly lines are larger, the energy projected by the zig-zag line is more dominant and draws your attention.

In this simple landscape drawing, we've mixed structural/geometric and fluid/organic into one subject. We've used line to create organic shapes in the sky, a horizon line with a geometric, structural silhouette of trees and an organic winding path at the bottom. Where is your eye pulled to over and over again? You might initially be attracted to the large, billowy cloud shapes, but you continually go back to the structural geometric zigzag of the trees on the horizon, which demands your attention. This tension causes the viewer to look from one area to another to another. Leading the viewer through the painting creates movement and also rhythm through that movement.

HIERARCHY OF SHAPE

For leading the eye, the triangle is a stronger shape than the square, which is stronger than the circle. It is useful to understand this hierarchy because you can use it to draw attention to an area or to tone down an area that may have too many aggressive shapes

For example, if your landscape has mountains or trees, or perhaps a boat with a triangle shape at the bow or stern, then these are the shapes that will catch the viewer's attention before the calm ripples of the water around them.

How will you lead your viewer's eye?

Simple shapes show how easy it is to communicate thoughts and feelings.

When you look at this shape, what does it symbolize? What does it mean when you see a straight line. Some might see a stick, or a road. What do you see?

What do you feel or think when you see a circle? An orange, the earth, a wheel, the cycle of life? This shape conveys many meanings.

What does this shape convey to you? How do you respond to the triangle? Perhaps you see a yield sign, a pyramid or a mountain.

These three simple shapes each convey ideas, or feelings. What happens when we combine these shapes? Does the meaning change?

Combining a circle and a line: What does this suggest to you? Do you still see a road and an orange? Probably not. As soon as shapes are combined, they elicit a different response. This might be a lollipop or a balloon, for example.

Everyone has drawn something like this to represent a girl. If we evaluate this sketch, we see lines, a triangle and a circle. These shapes are so powerful that we create a whole story by simply combining a few of them in an image.

Combining all these shapes in different sizes and in a different order communicates not only a face, but also the emotion in that face, a calm face. Imagine how you could change the angle of the eye-lines to make this simple face appear angry?

Begin with a circle, put lines outside the circle in a pattern. This changes the representation of the circle from a face to a sun.

Here's another example of combining two shapes, lines and a triangle, and it tells a new story. It could be a directional arrow. What do you see?

What happens when we add another triangle to the shape? This becomes a strong symbol of a tree.

Gallery: A Little Bit Blue
15" × 15" (38cm x 38cm), mixed media on cradled board

Several layers of self-leveling gel were applied between layers of paint, creating depth and resulting in a surface that you can see through to see suspended layers of paint. Except for a few mechanical areas that have low contrast (so your eye is not drawn to the area), the shapes in this painting are organic.

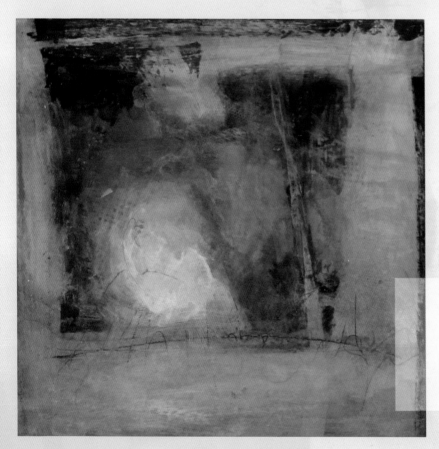

Gallery: Ray
15" × 15" (38cm x 38cm), mixed media on cradled board

This painting shows more signs of structure. You can clearly see the geometric shapes appearing across the center of the composition, but the edges are not hard and sharp, so organic is influencing and reducing the mechanical importance.

Developing my traveling exhibition *Farm Fragments* provided a great opportunity to use all kinds of materials to tell the story of farming on the prairies since the early 1900s. Although the shingle began its journey as a tree, the wood was milled into a geometric shape; weathering eroded the edges and encouraged moss to grow, swinging the cedar board towards the organic again. Documents and receipts, machine made with graphics, appear structural/geometric; torn edges and painted areas soften the mechanics of the original.

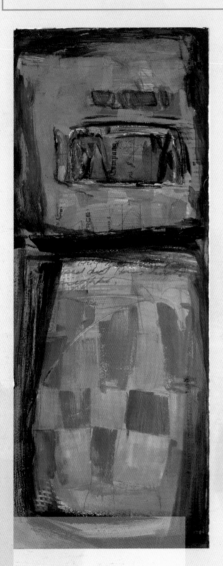

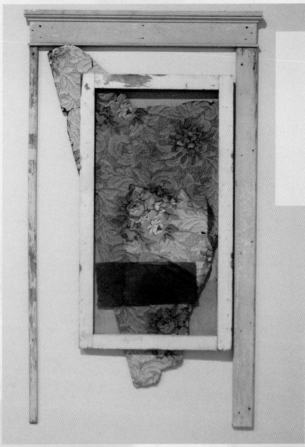

Gallery: Structural Assemblage
60" × 36" (152cm × 91cm), mixed media

The frame of the moldings and screen are off-balanced by the organic shape of the flowers and torn edges of the linoleum.

Gallery: Crop Failure
22" x 10" (56cm × 25cm), mixed media on paper

What does a prairie farm feel like? Although I was brought up in the city, when thinking of my family roots to the land, I think of my own experiences on the farm—smells, memory snapshots, stories from others—and then I paint. The land is gridded, scarred from machines leaving mechanical marks. I paint, I write thoughts and I balance shapes, colors, values provide a variety of edges until my painting is complete.

Gallery: Shingles
(assemblage)

Using shingles from the family farm, I arranged and carefully documented a pattern that can be recreated in each new exhibition venue. The pattern of the shingles is mechanical, yet capturing the wind-torn rooftop required variation within the size, spacing and connection between the negative and positive shapes.

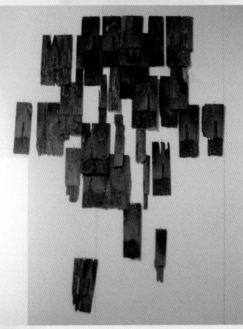

Mix, Then Pour

In this demonstration, you'll discover the interesting skins you can create by pouring from a container with a mix of fluid acrylic in self-leveling gel.

What You'll Need:

- container
- fluid acrylics: turquoise, Pyrrole Red, Diarylide Yellow, Quinacridone Gold,
- gesso (white)
- self-leveling gel
- surface of your choice

1 Pour some self-leveling gel into a container.

2 Squeeze some turquoise paint into your container with the self-leveling gel.

3 Repeat the process with Pyrrole Red and Diarylide Yellow, allowing the paint to move within the mixture.

4 Add Quinacridone Gold and white gesso to the mix. Turn the container around and from side to side to promote paint movement within the self-leveling gel.

5 Tilt the container and begin to pour the mixture onto your surface in the desired areas. The paint has not been allowed to mix thoroughly, so you will see lovely striations as you pour the paint.

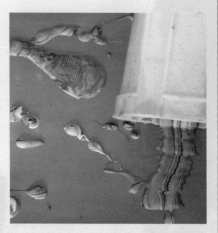

6 Try to create a wide pouring area with your paint and pour slowly. The result will be a lot like ribbon candy. Think about where you could apply this technique within your paintings.

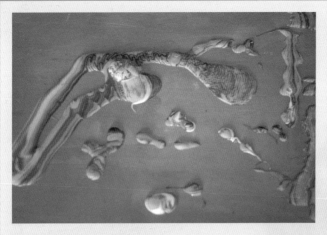

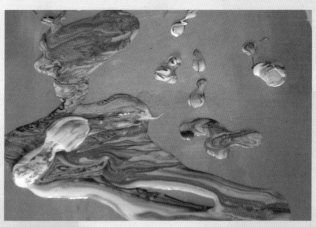

7 Finish pouring and look at the result.

8 Try tilting your surface to further encourage movement of the paint.

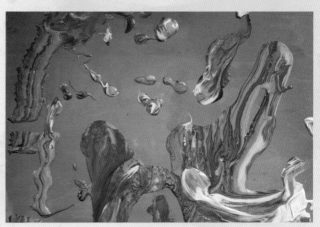

9 Try using a tool to spread out the paint where desired. I wanted to have some of the mixture mush together more and push to the edges.

10 The exercise is complete! Where the paint dries it will adhere to the board. The surface will accept subsequent layers of paint.

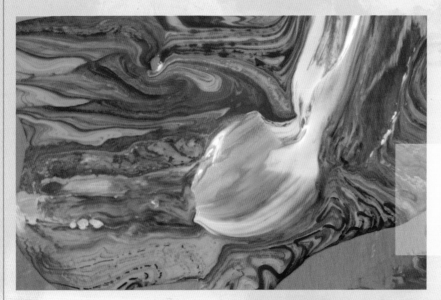

When the medium dries, it adheres to the surface and cannot be peeled off. You can see the taupe ground showing through the dried self-leveling gel. The tinted ground also reduced the intensity of other transparent colors.

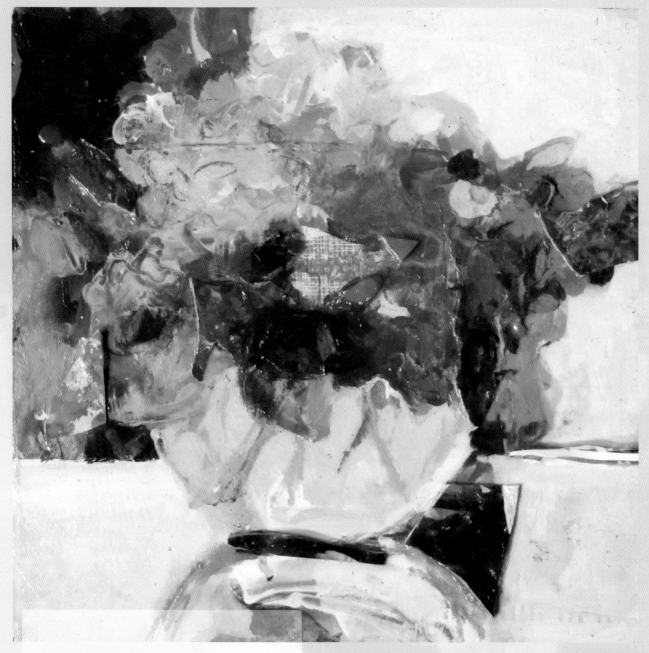

Gallery: Pieces in Balance
12" × 12" (30cm × 30cm), mixed media on paper, collection of the artist

Beginning with a surface that already had collage and paint on it, I superimposed a floral design and then went in with more collage for more relief. The grid area is part of the original collage, and you can also see watercolor crayon that shows through the many layers of different types of gels and mediums. I used self-leveling gel to build up the depth so that you look through these layers to see opacity and transparency.

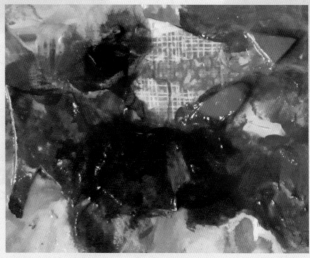

Creating a Skin

Pouring paint in any medium is really fun! Acrylic paint pourings can be developed on nonstick surfaces and then peeled off when dry. The loose dried acrylic paints, sometimes referred to as skins, are handy for use as collage materials.

Let's take a look at how you can develop a poured acrylic skin.

What You'll Need:

- fluid acrylics: Quinacridone Magenta, Hansa Yellow, Pyrrole Red, Diarylide Yellow, Phthalo Blue, Titanium White
- palette paper
- self-leveling gel

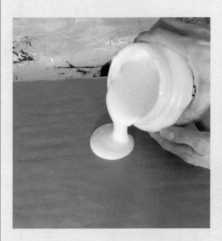

1 Pour self-leveling gel directly onto your palette paper.

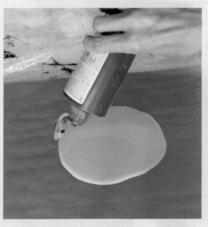

2 Drip and squirt Quinacridone Magenta into your pancake of self-leveling gel.

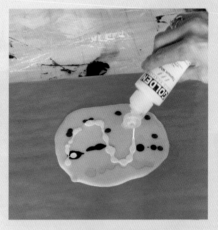

3 Repeat the same process with your other colors of paint.

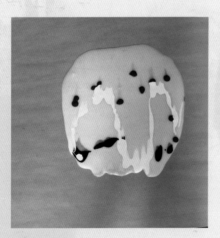

4 Once your colors have been dropped into the wet self-leveling gel, tilt your palette paper and allow the mixture to run and mingle within itself.

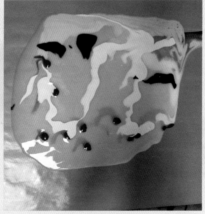

5 The more you tilt and turn your paper the more movement you will create within your self-leveling gel.

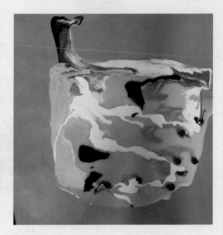

6 Continue tilting and shifting.

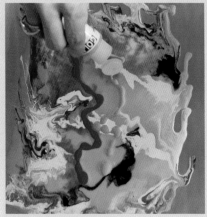

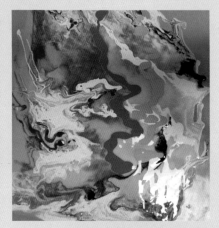

7 Continue with even more movement. This is a fun process!

8 Try adding more fluid paint to the gel and observe how it reacts with the paint that has already mingled.

9 Again, tilt and rotate the surface to encourage the newly added paint to move.

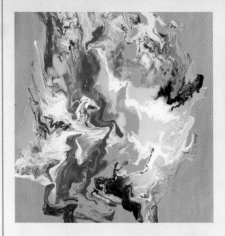

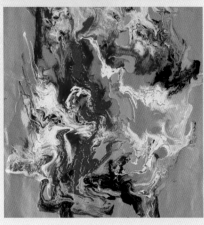

Here is the final result. When the products dry, the self-leveling gel will be transparent, while the white paint will be opaque. The cool thing about the use of palette paper is that the paint can be peeled off the surface and cut up and collaged onto another painting. You can use this technique directly on paper, board or canvas but it will stick to your surface when dry.

Here you can see that the self-leveling gel dried to show areas of palette paper below.

See how easily the dried acrylic paint peels away from the palette paper? This can now be cut and collaged into new paintings.

If you plan to save this piece of dried acrylic, ensure that you sandwich it between two pieces of non-stick paper.

Contributing Artist: Polly Hammett

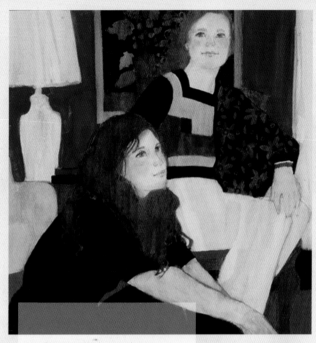

Sisters 1—Susan and Rebecca
14" × 18" (36cm × 46cm), mixed media on paper, private collection

My love of structure dictates my entire body of work. My interest in architecture, angles and straight lines seems to influence my painting and collage.

An architect, of whom was a student, said, after watching me work, that I built paintings: 'The original drawing represents the framework in a structure, the paint would be the walls, ceiling and floors. The finishing touches of the features, pattern and other embellishment added last are the lighting, plumbing fixtures and other finishing touches that are essential to complete the project.'

In my paintings, I design interlocking shapes with value that resemble puzzle pieces. By the use of contrast, I tie parts of the figure to the surrounding areas. By changing the opposing elements, I am able to redesign the painting over and over into different configurations. This structured way of working allows me to find the strongest design and gives me new ideas for future work.

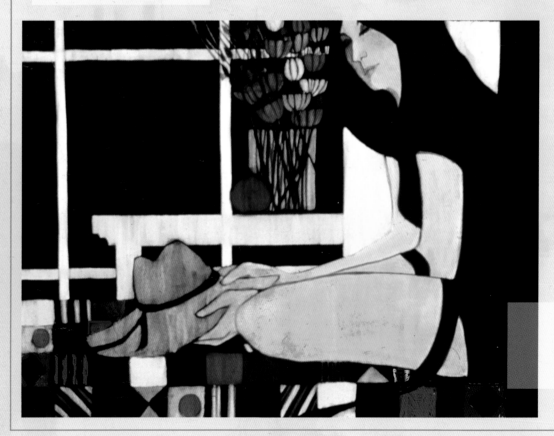

Ginn's Quilt
30" × 22" (76cm × 56cm), mixed media on paper, private collection

Contributing Artist: Donna Baspaly

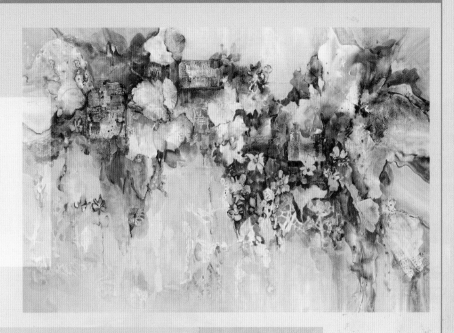

Finding Play
48" × 72" (122cm × 183cm), mixed media
on canvas

Many veils and opaque gesso have been
applied. If the work were organic in nature,
the shapes, lines and mark making would be
fluid, lyrical, curvilinear and maybe watery
in viscosity. The result of believing I am
the subject is that the work reflects my own
personal expression in every way I can render.

**Gwen and
Margaret Looked
On With Envy
As Sheila Lay
Another
Spectacular Egg**
48" × 48" (122cm ×
122cm), mixed media
on canvas

Mark making is a very
personal and Zen-like
experience for me.
I would get in touch
inwardly with how I
felt toward the subject
and the feeling would
dictate the way I hold
the brush, what move-
ment and mark making
I implement and what
shapes best depict the
subject. An example
of this is in the chicken
painting. I created an
environment by the use
of a staccato or scratch-
like movement. I tried to
allow my imagination to
get into the movement
of the birds as if I were
the bird pecking the
straw. There were strong
oval shapes for both
the chickens and eggs
and these shapes were
repeatedly used within
the environment.

Chapter 7
Subject Matter

We have covered tools and techniques for mixed-media painting; now it is time to explore the subjects you may want to paint. Why do you want to paint a particular subject? What is interesting to you?

The subject matter in a painting is chosen by the artist and may depict something referential (referring to a recognizable thing) or non referential (referring to something that does not symbolize something recognizable).

Referential imagery may be categorized as landscapes, figures, animals and still life.

Landscapes represent natural scenery like lakes, prairies, mountains and streams. Landscapes also include cityscapes or imagery of outer space.

Figure painting deals with the human form and may include nudes, portraits or people in an environment.

Still life paintings contain subjects that are stationary. Common objects for still life may be flowers, vases, ceramic or glass objects, household decorations, fabric, fruit, vegetables and books.

Animal or wildlife paintings gain inspiration from living creatures such as birds, pets, bears, deer and exotic animals like lions.

Abstract, nonobjective or non referential imagery does not describe a person, place or thing but rather relies on elements of design like colors, values, shapes, lines and textures to develop a painting. Often non referential paintings are developed through process, one mark leading the artist to choose the next. No matter the medium you are painting in, you are still making choices based on colors, values, shape, line and so on.

As you gain more experience, you may want to develop more meaning or a concept within your work. Ask yourself what is important to you; what do you want to communicate? Knowing your intentions will help you with your artistic journey. What do you want to paint? Formalize the subject that is meaningful within the painting process.

Gallery: Farm Field
10" × 10" (25cm × 25cm), mixed media on paper

*What do you want to say in your paintings? The subject is a big part of how you will communicate to the viewer. **Farm Field** is what I refer to as a memory painting. I thought of a story and a place and then tried to paint my thoughts and feelings with appropriate marks, colors and shapes. This farm field represents the land that was originally broken by my grandfather, with written text embedded into the image. The subject—the landscape—tells a story about the people and their struggle to survive.*

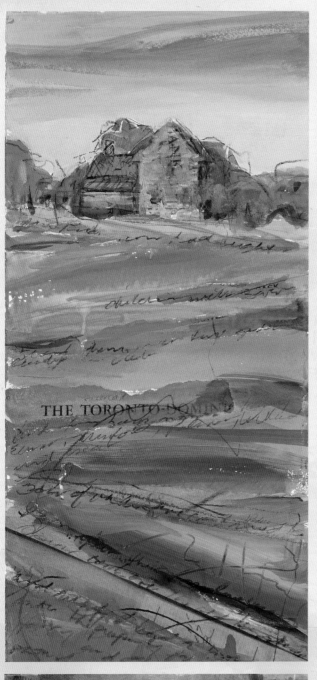

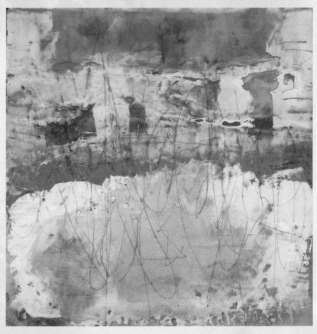

Still life, figures, animals, landscapes and abstracts all contain elements of design—value, color, shape, size, line/edge and texture. A color-field painting may consist of a range of colors in one family; referential imagery uses shapes organized into structures that will communicate the subject that you are visually describing on a two-dimensional surface. All subjects contain simple shapes.

In Chapter 6 we talked about shapes and how they are useful in communicating ideas. You can take those basic shapes and organize them to create any subject.

For example, the human face is a construction of circles, squares, rectangles and triangles. Those basic shapes can also be found within a landscape, still life, wildlife painting and some abstract imagery. Choose your subject and then get to know it; study the shapes that build the symbol that tells your story. The better you know your subject, the greater your confidence to express your own personal style.

Now you can take these common shapes and use them to build a variety of subjects within a painting. Here are a few examples.

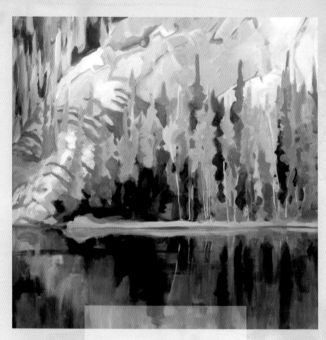

Gallery: Along the Parkway
30" × 30" (76cm × 76cm), mixed media on canvas

Learn to see simple shapes within your subjects. What shapes do you see? How do these shapes compare to the still life shapes?

Gallery: Landscape: The House that Hans Built
22" × 10" (56cm × 25cm), mixed media on paper
*Part of the **Farm Fragments** series, this is a memory painting. I'd remember the place and its stories, and I would just paint and write the stories into the layers of the painting. I used farm documents and receipts for collage.*

Gallery: Wildlife: On Alert
40" × 40" (102cm × 102cm), mixed media on canvas
I began with an abstract background, and simply by painting a few shapes and lines, we can communicate a deer through these symbols.

Gallery: Still life: Evening Light
12" × 16" (30cm × 41cm), mixed media on board
I prepared the surface with granular gel, and then drew my shapes. My living room provides wonderful opportunities for back-lit still life.

Gallery: Portrait: Comfortably Composed
12" × 12" (30cm × 30cm), mixed media on vellum
This is a fun, stylized impression of the figure. It is not high realism, so it's easy to take liberties with unpredictable colors, shapes and textures.

Gallery: Abstract: Elements of Red,
15" × 15" (102cm × 102cm), encaustic on board

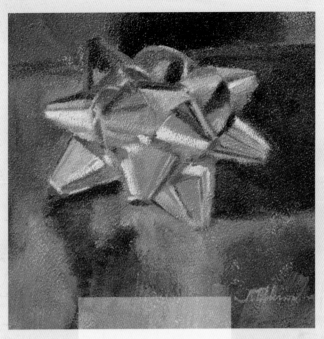

Gallery: Unwrapped
12" × 12" (30cm × 30cm), mixed media on board

The shapes in this still life are primarily structural with a few organic lines adding softness.

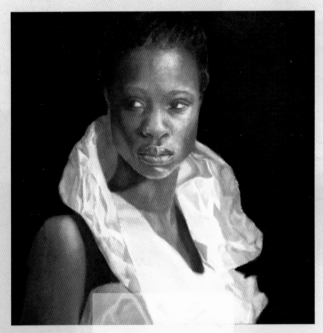

Gallery: Paper Rose
16" × 20" (41cm × 51cm), watercolor on paper

Portraits don't seem so scary now, do they?.

Gallery: Edge
*24" × 24" (61cm × 61cm),
mixed media on support,
private collection*

*Structural and geometric
shapes dominate in this
abstract and and represent
areas of light and dark.*

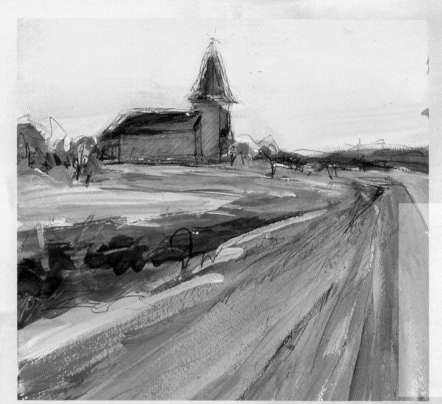

Gallery: The Pillar
*11" × 11" (28cm ×
28cm), collage, pencil
crayon and gouache on
paper*

*This memory painting is
about the church as the
pillar of the community
to celebrate life events.
 Are you starting to see
common shapes, no
matter the subject?*

Shape Comparison Chart

After breaking down each subject into its basic shapes, you can clearly see how the same building blocks are used for all subjects. Embrace the subjects that interest you, knowing that you will be able to communicate your ideas with these simple tools.

Shapes are flat. Form has roundness and implies a light source, which creates highlights and shadows. Every time there is a shift in the plane of the subject, the light or shadow changes, and more shifts mean more gradations in value. Each step in value creates its own shape. Learn to look for these shapes if your intention is to capture a more realistic style.

When you paint values within an image, train your eye to see the shapes of each value. When you use fewer, simpler shapes, your image will appear more flat to the viewer. The opposite is also true: Using more shapes offers more opportunity for describing realistic form through implying light source.

How are you going to describe your shapes? Color, value, line, form, size, texture?

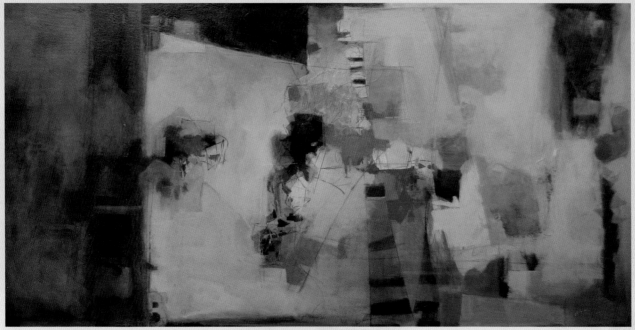

Gallery: The B's and D's

30" × 60" (76cm × 152cm), mixed media on canvas, collection of Mr. and Mrs. D. Johns

Because this canvas is the equivalent of two squares, it was both challenging and rewarding to break up the space in an aesthetically pleasing manner. Although it may seem like a non referential piece, most of my abstract paintings have a relationship with the land.

The first layers of paint are very organic in nature as I allow the paint to move, drip and drizzle. As the process develops more structure is implied onto the surface. The structure helps to calm the chaos that often ensues after a ground is prepared. I tend to like structural shapes more than organic ones but I believe that a presence of both strengthens a painting.

In **The B's and D's** the structural shapes are laid down with transparent or semi opaque paint first to allow the wonderful textures and colors to influence the successive layers. I think about where I want people to look and where I might enjoy areas of calm rest points. Geometric shapes draw the viewer's eye as well as strong contrast and pure color; I have used these ideas to help me lead the viewer's eye through the composition.

The B's and D's, bottom left detail, shows how shapes, lines and colors have been obscured by both transparent and opaque paint.

The B's and D's, bottom right detail, shows thick, dried acrylic collaged onto the surface.

Still Life Demonstration

In this demonstration, you will use basic shapes to describe a still life subject, a floral. My intention was to paint a floral with some meaning, so I gathered items from around my house to help tell the story. I used silk material with beautiful colors and textures, and set the vase atop an antique paint box to reference the past.

Choose a prepared ground or create one.

Apply several layers of paint and gels to the canvas, and allow yourself permission to play with the materials. Practice balancing colors, shapes, values, lines and textures. Developing a ground can help warm you up for the painting process, help you know your materials better, and develop a beautiful surface that will show through in places providing you with areas that are mature and satisfying.

This is one of many grounds started. Many layers of paint and gels were applied, much like our demonstration for doodles and dribbles in Chapter 3.

What You'll Need:

- acrylic inks
- brushes, assorted
- crackle paste
- fiber paste
- fluid acrylics and heavy-bodied acrylics: Hansa Yellow, Pyrrole Red, Quinacridone Magenta, Phthalo Blue (Red Shade), Cerulean blue, Ultramarine Blue and Cobalt Blue, Titanium White
- gesso, black and white
- granular gel
- mark-making tools
- pencil crayon, black
- pouring fluid
- surface a prepared surface from your explorations
- watercolor crayons

 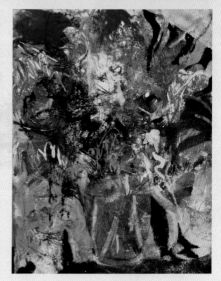

1 Have fun with your different mediums. Use crackle paste, granular gel, fiber paste, acrylic inks, watercolor crayons and mark-making tools.

2 Establish your strong shapes first to begin calming the chaos. Mix some red, yellow and blue into the black and add a bit of white. Begin to fill in some of the darker values.

3 Tone some white gesso with red, yellow and blue, and fill in some of the lightest areas to further establish basic shapes.

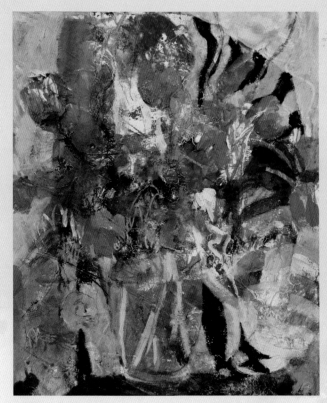

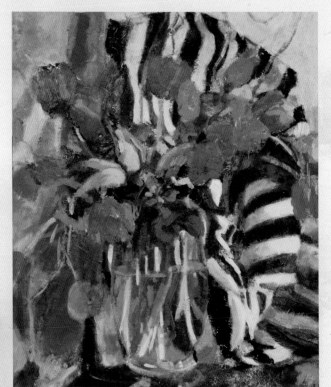

4 Brush on a blue strip in the background, using Cobalt, Ultramarine and Cerulean. Using Pyrrole Red, Quinacridone Magenta and Hansa Yellow, loosely paint some flower shapes.

Look at your painting. Think about its most important part. Are there areas that pull your eye away from that? Reduce the intensity of such areas. This piece is busy because of too many colors, shapes and value shifts. To deal with this, unite these with a single color, a transparent.

5 Look closely at the greens: Are they on the blue or yellow side? Look also at the values: Are they light or dark? Mix your own colors to match your intentions. At this point, try to link similar colors and values together in the foliage.

6 With each adjustment, continue to evaluate the painting as a whole. Does it feel comfortable? How much of the underpainting do you want to leave?

I intensified the reds in the flowers, pushed the blue stripe in the background back farther, added more eucalyptus leaves and continued painting black stripes. I also mixed some neutral putty-green colors for the shapes within the vase.

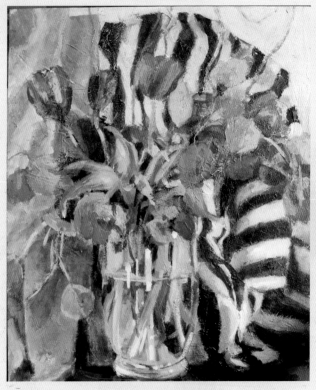

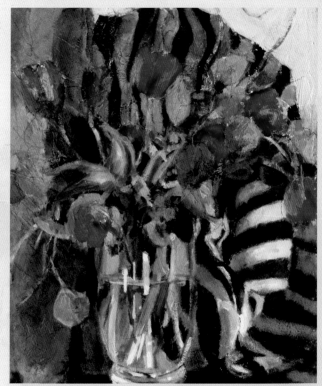

7 Be open to trying different things. Remember, it is just paint; it's just a surface. To give the illusion of more depth, use a transparent Phthalo Blue (Red Shade) to glaze in the background over the stripes at the top and right side. Glaze over some of the foliage in the center of the painting. To define the vase more clearly, push back light areas on either side of the vase and darken the paint box that the vase sits on. I also painted some brighter yellows on the left stripe.

8 I like a bit of color supported by neutrals. Each time I paint with lots of color, I end up painting over it with neutrals. So it is with this yellow stripe. I wanted the flowers to be most important, so I reduced the intensity of the blue and reduced the value contrast in the stripes.

9 After further glazing over background areas and adding more neutrals, apply a pouring fluid over the entire surface. The pouring fluid dries clear with a high gloss and really emphasizes the color intensity. Pouring fluid is a bit like self-leveling fluid when brushed on thinly.

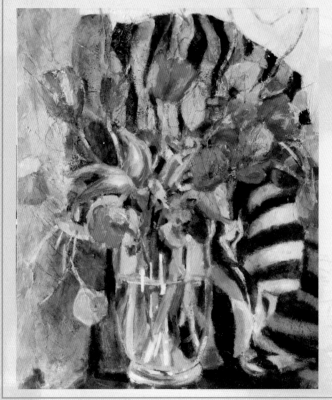

Gallery: Plethora of Patterns
20" × 16" (51cm × 41cm), mixed media
on board

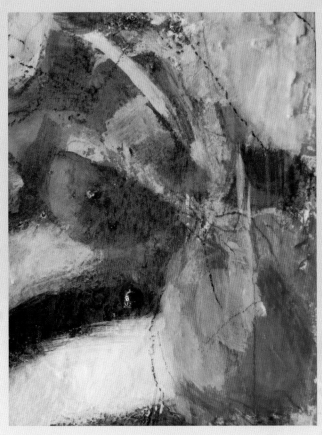

This detail shows the original surface in the tulip stalk and through other shapes.

Each shape is loosely constructed without laboring brushstrokes. Because of the built up layers of texture, a brush stroke over them gives a variety of edges while defining the shape.

This detail shows the original surface with the pencil crayon sketch showing through.

Contributing Artist: Mark Holliday

Leaving behind a background that had composed my character, I arrived in Calgary in 1984 and started working as a heavy industrial pipe fitter, servicing Alberta's vibrant petroleum sector. Perhaps provoked by this demanding environment or by the effect of radical change, I would often find myself returning, not in body but in reflection, to small corners of Northern England.

I love the landscape's invitation, wherever it may lead. Down some hill in the Lake District some small boy with a few items in a rucksack runs like hell past some large old tree and hurtles into his own front yard and stumbles, falls, skins his knee on the cobblestone, and contemplates crying but settles on a wince instead.

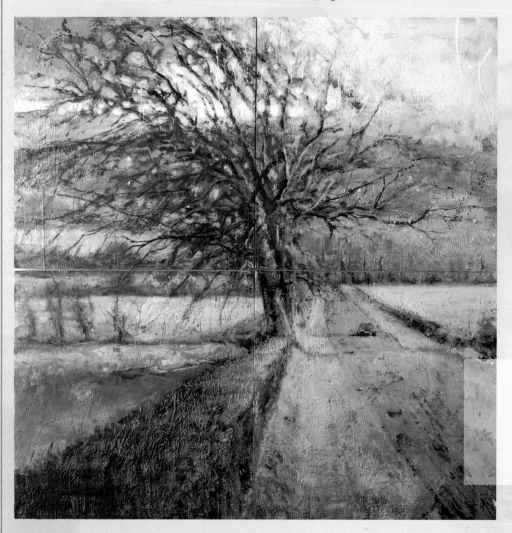

Landscape #03-12
96" × 96" (244cm × 244cm) (four panels, each 48" × 48" [122cm × 122cm]), beeswax, oil, digital image on panel. Collaboration with Aaron Sidorenko.

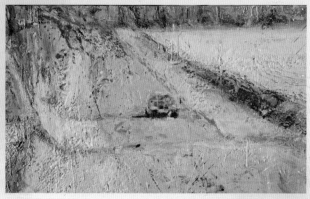

Gerhard Richter once noted, "The act of painting the banal speaks of a direct love of nature and humble things, a kind of diversion — a yearning for a whole and simple life." I identify with Richter's observations, as I tend to embrace my intuitive perceptions of space and time despite all the political and technological jargon of our contemporary society.

Contributing Artist: Suzanne Northcott

Because I see my subject as metaphorical, pointing beyond itself to other ideas and connections, there is no division between subject and concept. The objects in a painting (if there are objects) are always symbolic, possibly suggesting a cascade of thoughts and meaning to the viewer and often mysterious even to me. It makes the play between the object and the background, the figure/ground relationship, so intriguing to me, leading me to build ambiguity into the painting to reflect something I sense about my own relationship to my surroundings. I am a figure in a ground, an individual in a connected world, and I don't know where my edges are!

Lucy
48" × 36" (122cm × 91cm), acrylic, collage, graphite on cradled panel

Gallery: The Glance

16" × 20" (41cm × 51cm), mixed media on paper

After a lovely ground was prepared, I sketched a face onto the surface. The ground was very organic with a lot of subtle textures. I used both positive and negative painting techniques to pull the shapes of the portrait out while trying to retain as much of the supporting ground as possible. Collage papers were added to the surface as well as pieces of skins and chunks of dried acrylic paint. The intension was to paint the impression of a woman, allowing the transparent and opaque paints and collage papers to mingle between the subject and the background.

Chapter 8

Pulling It All Together

What is "pulling it together" and why do we need to think about it?

Have you ever started a painting with the intention of making the best image ever? So good that it would need to hang in a prestigious museum? You begin to paint, the colors are intoxicating, your brushstrokes dance on the surface and then slowly things fall flat.

What is your intention?

What is your story? How will you tell it? Will you endeavor to use referential or non referential, craftsmanship, technique, composition, design, emotional content, personal language or conceptual?

Which style will you use to describe your subjects? This includes all of the "isms," such as realism, post-modernism and surrealism, for example.

How will you organize these ideas on your surface? Organizing ideas requires the use of elements and principles of design.

Artists use basic building blocks to communicate ideas—value, color, shape, size, texture, line and edge—often referred to as "the elements of design." When we forget to use these elements wisely, our images lose strength and cohesion.

Our brains perceive some design elements more readily and more consistently than others.

Let's use the anatomy of our eyes to understand the strongest elements of design: value and color. Our eyes contain receptors called rods and cones; there are more rods than cones. Rods are more sensitive at recognizing darks and lights and movement. The rods recognize values but not colors. So we know that our brains perceive light and dark at a stronger rate than color.

Cones are fewer and less sensitive than rods. Within the cone family, red receptors outnumber green and blue. We notice red first and that is why fire trucks and danger signs are often painted with red.

Interestingly, people like structure and organization, but too much becomes boring. A helpful path for me is to try to make one design element dominant, with each additional element serving a lesser role. I think of design elements like characters in a play—a leading role, supporting actors and walkthroughs. If my painting is feeling less than cohesive, I look for a leading role and make sure it is dominant within the structure of the painting.

This may not be a simple thing as we know that value always trumps all the other elements. It is easy to make value the dominant element of design, but what happens if you want color to be the star? This, by the way, does not mean an absence of value, but instead that value contrast be reduced to not draw the eye, leaving color intensity to rule.

Dominance of Elements

These examples illustrate dominance by placing ripped pieces of patterned paper in different areas of the surface.

Areas of strong value contrast draw the eye and demand attention. Here we have a torn paper with black polka dots on a white background. The black and white contrast makes you look at the center of the surface where it is placed.

How can you balance a strong contrast and especially one in the dreaded center of the composition? Try a larger shape with less value contrast. Now the central strong contrast area feels more comfortable and not so central.

Let's add color to the balancing act. I tore an orange-red piece of paper and overlapped it onto the large shape. Now your eye would travel from the black and white to the orange-red and then explore the gray. Elements of design are now creating movement within the composition.

Let's see where we can make you look next. Try a complementary color on the left side of the orange-red shape. The viewer will now look from black and white to red and then to blue. Isn't it powerful to see how you can control where someone might look within your painting?

Take away the strong central contrast and replace it with a gray version. Color is pulling you, and your eye bounces back and forth from the complement to the gray square.

Change the gray piece in the center to orange-red. The two red shapes almost meld together; you will perceive the orange-red before the blue.

We still have a shape smack dab in the center, but it is not noticeable even with complementary colors. The new black and white shape steals the show.

The Hierarchy of Elements (Value/Color/Line)

Let's step back and think about the power of information within this painting. Many elements are evenly handled, so there is no dominance of color with an equal amount of red, yellow and blue. Value contrast, shape, color and size all vie for attention. Let's be more thoughtful in choosing a leading role.

The story in this sketch of an old bathroom sink is told first through value contrast and then color, shape, form and, lastly, line.

The same sink has a new leading character called color. The supporting roles are played by shape and then value and then edge/line.

Color and value did not make the top billing this time around. Here shape is the star! And then value and then color.

If shape is to dominate, then value contrast and color intensity must be reduced so that shape is recognized first. We have already discussed how the shape family has its own hierarchy and how geometric shapes are perceived before organic ones.

Poor line is not the strongest element in the list. Line is defined through value or color. Therefore, line suffers in a leading role. This example demonstrates how value pushes line out of top billing and into a supporting role.

By choosing a strong value contrast or an intense color or a triangle shape, we can direct the viewer to specific locations within our paintings and instigate movement and rhythm. We should try to have one of those elements be stronger than the others.

You can create different patterns of movement that lead the viewer through your painting by using the elements of design. Think about where you want people to look first, second, and third, and give them more reason to look in those places than anywhere else. You can try more traditional paths such as a Z, T or cruciform, for example, or try something a bit more unorthodox, like a central shape balanced or extreme edge placement balanced.

For example, perhaps we want the viewer to look at a specific flower in a still life. We must decide how to tell the viewer to look there first. Shall we use strong value contrast? Should we reduce the contrast and use intensity of color? Should we reduce contrast and intensity so that shape can draw the eye to that area? Size will draw the eye as well; large sizes will attract the viewer more than small sizes, and hard edges pull the viewer more than soft edges. So there are many tools to help us describe the story that we want our audience to see.

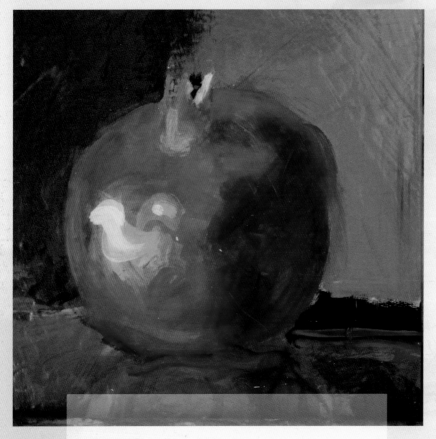

Each painting may have a different intention, priority and process. Every painter has their own unique sensibilities, their own process to move forward and their own way of evaluating. Work from your heart! Paint what is meaningful to you; it will show in your final result and read authentically.

Gallery: Pomegranate
8" × 8" (20cm × 20cm), mixed media on panel

In **Pomegranate**, *values that neighbor one another are not as strong in contrast as black and white. The value steps or differences are closer together in a value scale. The red of the pomegranate along with the size of the red mass becomes the leading role in this sketch, while value contrast comes in second and shape third. You look at the intense red color, move to the top of the pomegranate where the light contrasts the dark and to the triangle, then to the lower left where the dark line and the red streak are located. Don't forget the transparents and opaques; can you see them in the pomegranate?*

Working From a Theme

Working from a theme is a great way to explore a lot of different ideas and mediums—the theme tying everything together. Working with a theme can also help you build a concept and strengthen your visual language. You may be interested in environmental issues, technology, history, agriculture, equal rights, fitness and so on. What will you say about your theme and how will each new work support the ideas that you generate?

 I chose to work with my family history and the parallel of others across rural North America. My theme was important to me, and I had access to a wealth of artifacts to support my artwork and story. The freedom of working within a theme was liberating, and I learned a great deal about my process and myself.

Memory paintings: thematic example

Here is one example of memory paintings from *Farm Fragments*. You can find another on Chapter 7's introduction page (**Farm Field**). Each painting describes the land, and they have similar compositions.

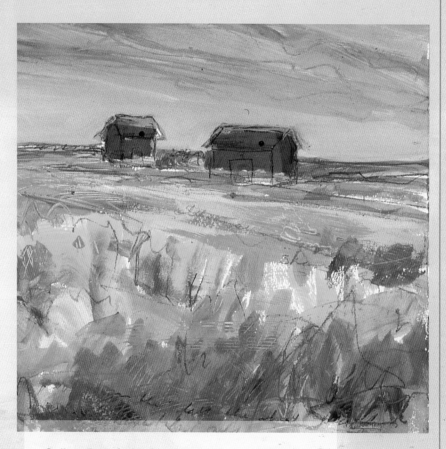

Gallery: Farm Series 2
10" × 10" (25cm × 25cm), mixed media on paper

There is something very freeing about working from memory. There is freedom in memory paintings to do whatever you want with choice of colors, textures mark making, placement of shapes; they are raw responses. My memory paintings are very loose, almost like a fleeting thought allowing the instant reaction from the last mark to direct the next line or brush stroke.

Ideas for Composition

These examples illustrate ideas for composition by placing ripped pieces of patterned paper at different spots on the surface.

Traditional sweet spots for your center of interest are arrived at by dividing your surface into thirds; your sweet spots are located where the lines intersect.

An orange-red swatch placed along the top edge of the surface; it feels extremely off balance.

Nontraditional thought disregards mathematical sweet spots and places the interest away from them. Abstract impressionists pushed interest to the outside of the painting; this worked because the elements were thoughtfully balanced within the composition.

Now the image feels balanced and comfortable as a result of a larger orange-red shape placed at the opposite edge of the composition.

You can place your focal point anywhere, but be sure to balance it in a thoughtful manner.

Tulip Exercise

This is a simple illustration of the many options available for designs from one image.

How will you arrange your pattern? What elements will you use to describe your shapes and lead the eye through the composition?

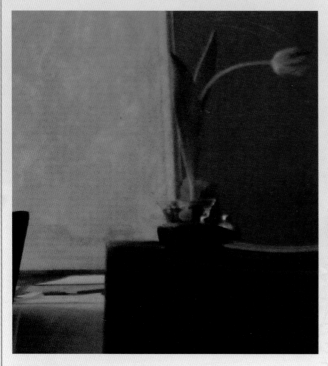

Cropped photo of a table with a tulip in a vase

Value sketch of the photo

I cut a piece of vellum in the same proportions as the sketch and drew on representative shapes.

I carefully cut out each shape to form a puzzle-like effect and placed all the shapes on a surface with a different color or value background.

Next I experimented with removing and replacing parts of the puzzle, allowing the background to show. Some arrangements look better than others. Choose your favorite and use the pattern in your next painting. (Arrangements with a dominance of light or dark are the ones that appeal to me the most.)

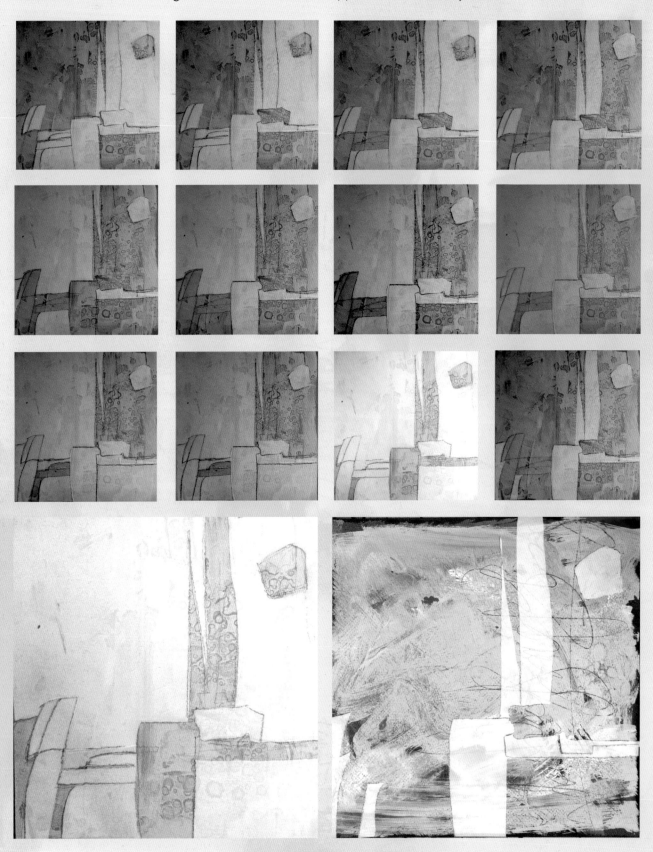

Wrapping Up the Concepts

Content is always important as it speaks to what you want to communicate within your painting.

Our society has a very disposable element that flows over to how we treat our citizens. As we age, we are often perceived to be less valuable than the young and beautiful; women I believe feel this syndrome the most.

I chose to implement collage into my process as I had some wonderful mechanically numbered paper. *Marginalized* uses many of the techniques discussed—lots of opposites like thick and thin paints, transparent and opaque mediums, organic and structural elements, complimentary colors, pure and neutral colors, form filled and flat shapes.

Let's take a look at how these ideas have been applied!

What You'll Need:

- brushes, assorted
- fluid acrylics and heavy-bodied acrylics
- found objects
- gesso, black and white
- heavy gel
- matte medium
- pencil, black
- support: a prepared surface from your explorations
- tissue paper

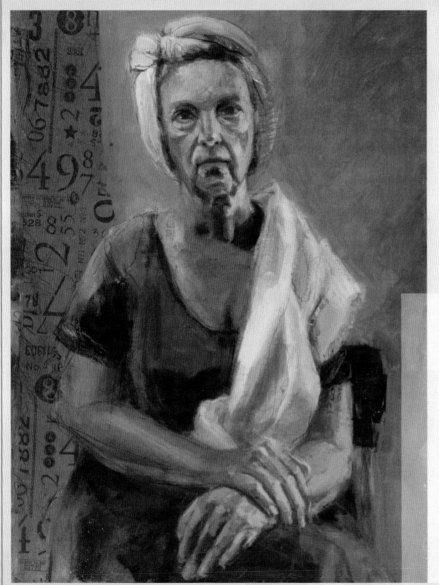

Gallery: Marginalized
20" × 16" (51cm × 41cm), mixed media, collage and acrylic mediums on cradled board

In much of my past work I've thought about opposites—transparent and opaque, round and flat, and so on. This demonstration is an example of something organic and something mechanical playing against each other and creating some tension. This piece is intended to symbolically tell a story about aging in our society. Even though it is on the side of realism, it is about the marginalization of women as they get older, hence all the numbers are collaged into the finished piece. The numbers imply that over time, our numbers get larger with our age and that comes at a price because our society extols youth. As we get old, we tend to become invisible; we are thought to be less attractive.

1 Draw a loose graphite sketch of your subject, breaking down the model into simple shapes.

2 Prepare the ground using whichever mediums and techniques you prefer. Sketch your image on top of the ground using a brush and paint. Simple shapes can be used to block in the composition.

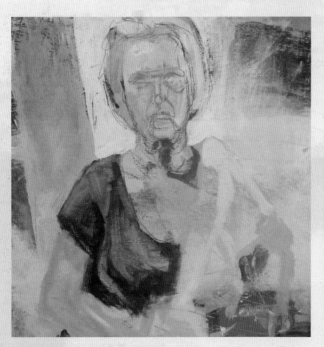

3 To calm the surface, use opaque paint to define some of the outside negative shapes around the left shoulder. Positive painting can be utilized to define the elbow and parts of the dress. As line is a favorite element of mine, I took time to include it with a pencil.

4 Continue to use simple shapes to develop detail. This detail shot of the hands shows how simple shapes are used to block in and define the hands.

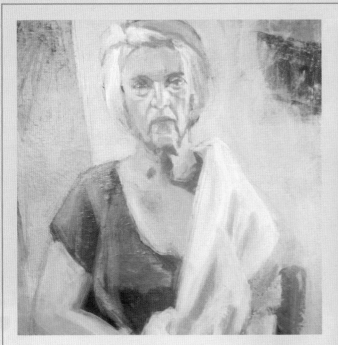

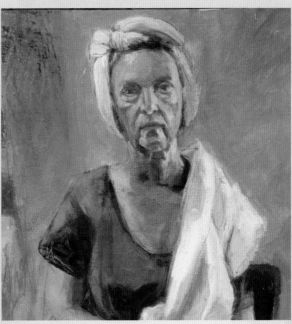

5 Glazing can be a great tool to tie your painting together. By glazing, you can add unity through color and temperature. Although I am not a fan of pink, at this stage, I needed to unify everything I have going on here. The pink dominance is only temporary and it does achieve its purpose.

6 So what would happen if you added a complementary color to the glazing you just laid down? Doing exactly that, add lime green to establish a color pattern.

7 Now begin incorporating collage. With this piece, I wanted to communicate the dominant media trend and public perception of aging, and in particular, how we devalue women as they age. (While this lovely woman is not elderly, she is not in her youth.)

Take tissue paper printed with numbers and add it to the figure and to the background, carefully balancing the graphic quality with the organic feel of the woman.

Use matte medium over the top of the tissue as it will soak through the tissue. The thinner paper can be affixed using medium just on the top. By adding the tissue to the subject and the background, the painting is balanced.

8 Apply matte medium on top of the small pieces of tissue paper to adhere them to the surface.

9 To adhere larger tissue pieces, paint the surface with medium and gently place the tissue on top. The matte medium will soak through the paper and thoroughly glue the collaged piece to the surface.

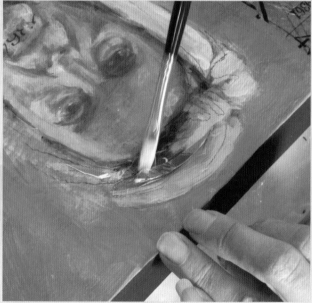

10 When it comes to something chunky, like these big chunks of dried acrylic from my palette, use some heavy gel on the back.

11 Smooth around the edges so there are no big globs of medium to dry afterward.

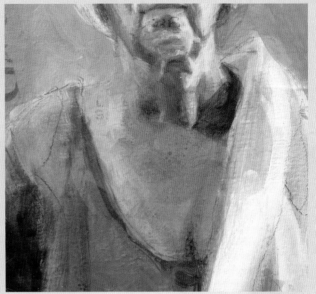

12 For a larger collage piece with heavy gel, place a piece of nonstick paper like wax paper over the applied area, and use a brayer or a metal rolling pin to flatten the gel and smooth out the undulations on the surface.

13 Once these are down, you don't want the mechanical part to take over the focus of the painting, so obscure it with transparent paint. The glaze kicks back the value contrast between the black numbers and the skin tone so the numbers don't draw too much attention. You really have to look closely to see the numbers in her chin and shoulder. Repeating that mechanical iconography over and over throughout the painting helps to tell the visual story. The painting should look good from far away; up close you see all these little jewels popping out.

14 Look at your work and learn to see balance, unity and comfort. I went back in and added a few touches of color here and there to strengthen the image. The model is more important than the numbers, but the numbers support the visual imagery.

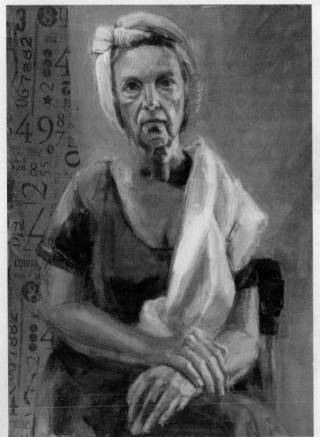

To see a more detailed step-by-step demonstration of the creation of this painting, please visit CreateMixedMedia.com/ MMPW-companion

An Artistic Journey

Well, here I am at my current destination. As with any journey, I can always travel back to my roots and paint a lovely watercolor, but staying there in one spot was not part of my destiny.

I am excited about where I have been and what I have learned along the way. It has not always been easy, but pushing through those times leads to the most growth.

Because I had the courage to leave my comfort zone and explore I can now tell my visual story in a much different way and that is exciting! I hope you will consider mapping your journey in a similar way.

I began my journey with Paper Rose, a referential and realistic painting. There were, however, a lot of adventures prior to this image, things like knowing my pigments, pushing water, color, transparents and opaques, introducing gouache, exploring opposites, adding acrylics, using collage and so on.

Consider the descriptions of the paths I've taken and the stops along the way to be a map key or legend of sorts—I've accounted for style, technique, purpose, emphasis, mindset and more. Consider marking your own journey in a similar way, including whichever information best tells your story!

A path to adding other mediums

A1
Referential—more realistic
Traditional watercolor on paper with gouache, gesso, acrylic paint, gold leaf and pencil crayon added in a controlled manner. Organic and geometric opposites applied.

A2
Referential—more realistic, conceptual
Traditional watercolor on paper with gesso, ink, acrylics and pencil crayon added in an uncontrolled or fluid manner. Structural and fluid opposites applied.

A3
Referential—more impressionistic
Transparent and opaque ideas applied to board. Flattening shapes applied.

B path to loosening up

B1
Referential—more impressionistic, conceptual
Exploration from working with a theme helped build the foundation for an abstract ground. The shapes are primarily flat.

C path to new ideas with old subjects

C1
Referential—more impressionistic
Using a different subject, a still life, and working on top of a textured surface.

D path to introducing collage

D1
Referential—more realistic, conceptual
Adding collage to the surface structure and then imposing an image on top. Allowing some areas to be obscured while others peek out and show the original surface.

D2
Referential—more impressionistic, conceptual
Adding collage within the painting process. Transparent, unusual placements, opaques and obscuring.

E path to working with a theme

E1
Referential—conceptual
Using found objects to create assemblages.

E2
Referential—conceptual
Using Polaroid transfers with fluid gesso, ink, acrylics and gold leaf.

E3
Non referential—conceptual
Found objects used in mini assemblages as in non referential collages. Balancing of elements is incorporated.

E4
Referential—more realistic; Non referential—conceptual-memory painting
Utilizing collage with transparent and opaque paints, writing thoughts into the surface.

E5
Referential—conceptual
Using found objects to create assemblages, working in 3-D to develop assemblage.

E6
Referential—conceptual
Taking ideas of balance, transparent, opaque, obscuring, pure color vs. neutral to develop composition. This could be non referential, but I was thinking of the land when painting.

F path to unusual emphasis

F1
Referential—conceptual, simplified imagery
Mixing mediums and collage.

F2
Referential—conceptual, simplified imagery
Collage with relief. Making the elements the focus.

F3
Referential—conceptual, very simplified imagery
Collage with relief.

G removing the traditional subject although initial thoughts are on landscape

G1
Larger Scale Non referential—conceptual
Division of space and balance is the focus with mixed media and collage. Experience from paths traveled is utilized in these images.

G2
Smaller Scale Non referential—conceptual
Division of space and balance is the focus with mixed media and collage. Experience from paths traveled is utilized in these images.

Next Stop in the Artistic Journey!

The Glance on the opening page of Chapter 8 began with a non referential image, a wonderful mixed-media ground. After developing an appealing surface, I superimposed the drawing of the girl. The finished painting includes many layers of mediums and paint, transparents and opaques, glazing, scrubbing, splattering and stamping, negative and positive painting, writing my thoughts, weaving collaged papers and dried acrylic chunks onto the surface, structural and organic shapes, thinking about where to lead the viewer's eye through the painting, value contrast, pure and neutral colors, shapes, textures, line and the theme of people and a partridge in a pear tree! I love where I am in the journey and can't wait to continue the journey forward.

A piece of collage on the eyelid was cut to the specific shape of that value so it reads as belonging to the eye. At the right side of the head, the collage piece had shapes that implied a hairline, so I integrated it to support the shapes I wanted to describe.

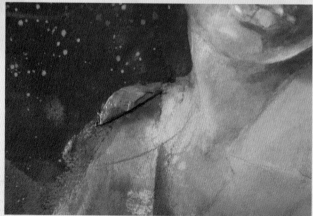

Relief resulted when this thick chunk of dried acrylic was collaged on to the shoulder of the subject. Collage is successful when you stand back and the collage is cohesive within the painting.

Contributing Artist: Virginia Cobb

I was a graphic designer before I became a painter, moving shapes around within a two-dimensional space until they were perfectly synchronized. As a result, I look for the same kind of design in paintings—a subtle interaction among the separate units, the way each shape responds to its surroundings, the connections that bring it all together.

Every artist has downtimes, which I believe are essential to survival. If I were to try to maintain a constant creative state, I would burn out quickly. There are times for outward expression of our inspirations and times for looking inward and reflecting. If I do not allow myself time out occasionally, I become one-dimensional and so does my art.

An artist does not have an off/on switch; we're always on. No matter where we are or what we're doing, we are absorbing—gathering ideas, colors, shapes—even if not consciously. These collected influences insinuate themselves into the work in some way at a later time. I give myself periods of time to catch up with friends, to read, to study, to go to galleries, to just be, without obligation.

People who work the land know that if they allow for a fallow season—allow the earth to rest—they will see renewed energy in the next planting season. If I allow myself a season of rest, I always come back to the studio with increased creative drive and new ideas.

Secret Societies
*32" x 40" (81cm x 10cm),
acrylic on board*

About the Contributing Artists

BRIAN ATYEO

Brian is well known for his bold and spiritual depictions of jazz, figures and the Canadian landscape. His work is a constant exploration of color and form showing remarkable confidence.

Born in Toronto, Brian worked as a freelance artist before moving to Calgary and taking a position as an illustrator apprentice. Independent study, commercial illustration and creative painting played an important role in the artist's development in the ensuing years. By 1980 Atyeo was showing his work throughout Canada, devoting his time fully to painting. He is a member of the Canadian Society of Painters in Watercolour and the Ontario Society of Artists. See more of Brian's work at **harbourgallery.com**.

VIRGINIA COBB

Virginia Cobb is a native Oklahoman who grew up in a family of artists and has been actively involved in art throughout her life.

She now lives outside of Santa Fe, NM, where she makes art and teaches workshops. She was elected to the American Watercolor Society in 1976. She is also a member of the National Academy of Design. Her watermedia paintings have been exhibited throughout the U.S., Canada and Great Britain and hang in many corporate and private settings.

She believes that every painting is not a style of painting or a school of art—it is an attitude, a willingness to take risks, because there is no guarantee that a painting will turn out well. Learn more about Virginia and her work: **virginiacobb.com**.

KATHERINE CHANG LIU

Born in China and raised in Taiwan, Katherine Chang Liu received a full scholarship to UC Berkeley, where she received her MS in science. After moving to Virginia with her husband, she rekindled her love of art and the brush painting she had practiced as a child. Her work has won many awards and has been featured in dozens of magazine and newspaper articles. Liu has served as a sole juror and co-juror for numerous national, regional, state and local competitions. Katherine has had solo shows in Denmark, Finland, France, Hong Kong, Italy, Taiwan, San Francisco, Los Angeles and Santa Fe. She is a recipient of grants from the NEA and Virginia Commission for the Arts. Her work can be found in more than 950 public, private and corporate art collections. In 2012 she received the Lifetime Achievement Award from the Watercolor USA Honor Society. To see more of Katherine's work, visit **chiaroscurosantafe.com**.

DONNA BASPALY

Donna Baspaly has exhibited worldwide and won many prestigious awards. She writes and is featured in international magazines and art books and continues to be profiled on TV and radio. The Federation of Canadian Artists and the Northwest Watercolor Society honored Donna with Senior Signature status and a lifetime honorary membership. Her art has been purchased by corporate collectors and showcased by leading Canadian designers. Baspaly is a popular international workshop instructor, mentor and a sought after juror. She serves annually on the FCA Standards Committee as well as being a juror for various national and international art competitions. Visit **kurbatoffgallery.com/artists.htm** to see more of Donna's work.

MARK HOLLIDAY

Mark's family moved from Calgary to England when he was a child. Most of his youth was spent in the English Lake District, famous for its profound beauty. After leaving school he worked as a welder but often indulged his artistic urges through sketching and painting.

In 1984 he returned to Calgary. Eventually he quit his day job as a pipefitter and enrolled in a fine arts course at the Alberta College of Art and Design. He graduated with honors in 1994 and is one of the founding members of Untitled Art Society. In recent years he has become recognized as an accomplished painter, his work offering an unusual approach to traditional landscape painting. Visit **markholliday.com** for more.

POLLY HAMMETT

Polly Hammet has been elected to the American and National Watercolor Societies and is listed in *Who's Who Of American Art* and *Who's Who of American Women*.

Her work has been selected for numerous juried exhibitions that include the American, National and San Diego Watercolor Societies, Philbrook and Oklahoma Art Centers, Tweed, Frye, Laguna, Oklahoma City, Tucson and Albuquerque Art Museums and Watercolor USA. Her awards include the Clara Stroud Memorial Award at A.W.S. and purchase for the permanent collection at the Albuquerque Art Museum.

Since 1985 she has served as juror and curator across the United States for more than 100 exhibitions that include A.W.S., and Polly has instructed more than 200 workshops in 41 states since 1983. Visit Polly's website: **pollyhammett.com**.

MAXINE MASTERFIELD

A graduate of the Cleveland Institute of Art and a resident of Sarasota, Florida, Maxine Masterfield is an active member of the American Watercolor Society, the Kentucky Watercolor Society and the Florida Watercolor Society. She is the founder of the International Society for Experimental Artists and the publisher of *Painting the Spirit of Nature and In Harmony with Nature*. Her video, *Painting with Maxine Masterfield*, is available as a teaching tool. Maxine juries and conducts workshops throughout the United States and especially enjoys teaching at her studio in Sarasota at the artists' colony of Towles Court. Visit her website, **masterfield.net**, for more information.

SUZANNE NORTHCOTT

Suzanne Northcott is an interdisciplinary artist working with installation, video, painting and drawing. She is interested in the shifting place where one thing becomes another, studying dreams and meditation and themes of transformation, decay, metamorphosis and migration. This interest in the space between also manifests in her continuing history of collaborative work with poets, scientists and artists in other genres. Northcott's work is held in numerous collections including the Surrey Art Gallery's public collection. She is a sought-after lecturer and instructor; as workshop leader Suzanne often combines international cultural excursions with painting and yoga instruction.

Find more at **suzannenorthcott.ca**

ELISE WAGNER

Elise Wagner has been a working artist for nearly thirty years. Her fascination with science led her to earn a Bachelor of Science degree from Portland State University with a major in painting and printmaking. Using the many symbols found in astronomy, physics and alchemy, Wagner's work aims to reflect the seemingly illogical and arbitrary order inherent in today's uncertain world.

Her work is among private and corporate collections throughout the United States. Wagner exhibits her work at Chase Young Gallery in Boston and Butters Gallery in Portland, OR. Most recently, Wagner was a panelist at the 6th International Encaustic Conference. Her work is soon to appear in the 2013 book *100 Artists of the Pacific Northwest*.

Check out Elise's website, **elisewagner.com** for more.

JEREMY MAYNE

Jeremy Mayne completed his M.F.A. at the University of Calgary, including studies at the Royal College of Art, London, England. He is a member of Calgary's Artist's Circle and the Alberta Society of Artists. Jeremy's work is in numerous collections, both national and international. As an instructor he has 23 years experience teaching art and has facilitated a great number of workshops to artists throughout Alberta. As a practicing artist Jeremy runs Blue Willow Studio. To learn more about Jeremy and view his latest works, visit: **3degreestudio.com**.

COLLEEN PHILIPPI

Colleen Philippi's artwork immediately captures the attention of the viewer. A sense of mysticism comes from her highly creative and personal visual vocabulary of secrets, treasures, allegories, astronomy, poetry and memory, working to create unique moments in time.

Stylistically and conceptually, Philippi is assembling from visual building blocks: partial and full letters, word fragments, signs, basic geometric shapes and patterns, color samples, paint and color palettes, pieces of isolated or displaced furniture, human anatomy, images of landscapes, insects, butterflies, etc. Combined, all of these simple components work together to create meaning to which the viewer adds his or her own significance.

Visit **newzones.com** to see more of Colleen's work.

AARON SIDORENKO

Aaron paints to defy mortality.

Learn more about Aaron at **aaronsidorenko.ca**.

To learn more about the contributing artists and for easy links to their work, please visit CreateMixedMedia.com/MMPW-companion.

Resources

Golden Artist Colors
paints, mediums/additives, gessoes/grounds
www.goldenpaints.com

Heinz Jordan & Company
paintbrushes
www.heinzjordan.com

Gallery: Through His Eyes
10" × 10" (25cm × 25cm), mixed media on paper

*Dripping and pouring techniques were incorporated in the initial stages of **Through His Eyes**. Pieces of vellum and dried acrylic chunks were collaged to the surface of the image for diversity.*

Index

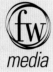
Distributed in Canada by Fraser Direct
100 Armstrong Avenue
Georgetown, ON, Canada L7G 5S4
Tel: (905) 877-4411

Distributed in the U.K. and Europe by
F&W MEDIA INTERNATIONAL
Brunel House LTD, Newton Abbot, Devon, TQ12 4PU, ENGLAND
Tel: (+44) 1626 323200, Fax: (+44) 1626 323319
Email: enquiries@fwmedia.com

Distributed in Australia by Capricorn Link
P.O. Box 704, S. Windsor NSW, 2756 Australia
Tel: (02) 4560-1600
Fax: (02) 4577-5288
Email: books@capricornlink.com.au

ISBN-13: 978-1-4403-2507-6

Edited by Kristy Conlin
Designed by Amanda Kleiman
Production Coordinated by Greg Nock

Acknowledgments

It is difficult to put into words the gratitude that I feel for the wonderful opportunity to write a second book with North Light. This book would not be possible without the community of family, friends, neighbors, students, patrons and associates that surrounds and supports, my artistic journey.

I would like to thank God for the inspiration, determination and ability to paint and for the opportunity to share my knowledge in this publication.

The staff at North Light Books have been incredible to work with over the years and I truly appreciate their support, guidance, knowledge, advice and friendship. I would like to thank:

Jamie Markle, publisher and editorial director, for his encouragement, support and thoughtfulness.

Pam Wissman, senior acquisitions editor for listening to the initial idea and Tonia Jenny, acquisitions editor, for believing in the concept and sharing her enthusiasm to work with me on this project.

My editor Kristy Conlin has been a real gift; she brought her knowledge and expertise to the editing table, guiding me with an openness and sense of humor that was so very much appreciated!

I would like to give a sincere thank you to Golden Artist Colors, Inc. and their staff (especially Jodi O'Dell and Paul Schulz) for facilitating their generous technical and product-based assistance.

To Heinz Jordan and president Birgit Cooper, a special thank you for their assistance and support.

Maureen Bloomfield, Paul Koegler and Olga de Sanctis, a special thank you for continued friendship

and support. It is always recognized and treasured.

Mixed Media Painting Workshop is enhanced by the involvement of all of its contributing artists through the generous sharing of their fine art and insightful thoughts. I thank each and every one of you as you truly made this book a stronger one.

A special thank you to Patricia Bacon for her time, expertise and generous assistance throughout the development of this book. Thank you to Susan Simister, for her time, support and attention to detail!

A heartfelt thank you to my family, for their encouragement and hugs when I needed it most. To my parents, Doris and Willard Pederson, for a lifetime of inspiration and love; my husband, Douglas Kerr, and sons Ryan and Scott for sharing this adventure, I couldn't have done it without you beside me!

About the Author

Jean Pederson is an accomplished artist who balances painting with teaching and writing. Although well known for her mastery of watercolors, mixed media has become an important vehicle for her creative expression.

Jean's traditional practice includes referential imagery of people, still life, landscape and non-referential imagery. Layering of mixed media offers an assortment of possibilities; shifts in quality of edge, line and texture support concepts that she explores within her multidisiplinary work.

She is a contributing editor for *The Artist's Magazine* and her work has appeared in several of the *Splash* best-of-watercolor series as well as *Watercolor Artist*, *Magazin'Art* and many others. Jean has authored two books and has released four educational DVDs.

Included in Canada's *Who's Who* Jean is a signature member of the American Watercolor Society (AWS), California Watercolor Association (MCWA), The Federation of Canadian Artists (SFCA), the Canadian Society of Painters in Watercolor (CSPWC) and the Alberta Society of Artists (ASA).

Jean has been honored with numerous national and international awards over the years, and has work placed in the Royal Collection in Windsor, England. She was the first recipient of the Federation of Canadian Artists Early Achievement Award, recognizing her many honors and awards for consistently exceptional painting, and for her international writing to promote art education. Most recently, Jean was awarded the Queen's Diamond Jubilee Medal for contribution to the arts.

Jean Pederson has exhibited her work both nationally and internationally in museums and galleries in China, England, Sweden, the United States, Mexico and across Canada.

A popular instructor throughout North America, she has led workshops at colleges, professional organzations and symposiums and has juried national and international exhibitions.

Visit Jean's website at **www.jeanpederson.com**.